ARTS MANAGEMENT IN THE '90s:

The Essential Annotated Bibliography

ARTS MANAGEMENT IN THE '90s:

The Essential Annotated Bibliography

by

Nik-ki Whittingham

ENAAQ Publications
Chicago

Published and distributed by:
ENAAQ Publications, Inc.
P.O. Box 1375
Chicago, IL 60690

(312) 643-4247

Whatever you do, do it good.

Miles Dewey Davis II

Arts Management:

The act, manner, or practice of controlling, guiding, managing,
or supervising the career and business affairs of an artist or an
arts-related business establishment, organization, or institution.[1]

The purpose of this bibliography is to provide the educator, manager, entrepreneur, and

promoter with contemporary reference books to assist in teaching and making day-to-day

business decisions. Research revealed that the latest arts management bibliography was

compiled in 1980. Incuded here are a few industry standards from the late '70s, but the

majority of the 419 entries include books written in the 1980s. This is an important aspect of

the bibliography, because technology haschanged the way we teach, create, and produce.

It is hoped that with these reference materials, the arts manager will better be able to

bridge the space between artists and their audiences.

[1] Charles Suber, Professor, *Seminar: Arts Management*,
Management Department, Columbia College Chicago.

1

The ABC of Copyright. UNIPUB, 1981.

2

Adler, Bill. *Inside Publishing*.
Indianapolis: Bobbs - Merrill Co., 1982.

3

*Advertising & Publicity Resources
for Scholarly Books*. New York:
Association of American University Presses,
1988.

Categories are academic. Each entry,
mainly periodical, is broken down by title,
subject, language, founding date, frequency,
circulation, distribution percentage, contacts,
address, and phone number.

4

Albert, James. *The Broadcaster's
Legal Guide for Conducting Station Contests
& Promotions*. Bonus Books, 1985.

5

Alkire, Leland G., Jr., compiler.
The Writer's Advisor. Marshalltown, IA:
Gale Books, 1985.

"Arranged in 34 topical chapters.
Each chapter begins with descriptions of

relevant books, followed by bibliographic citations to magazine articles. Altogether, some 800 books and "3,000 magazine articles are identified."

6 Althouse, Jay. *Copyright: The Complete Guide for Music Educators*. Music in Action, 1984.

7 American Artist Business Letter. *Contracts for Artists*. New York: Billboard Publications, 1979.

"A short booklet with model contracts for visual artists and brief explanations for the use of each one."

8 *American Book Trade Directory*. 35th Edition, 1989-1990. New York: R.R. Bowker Company, 1989.

An invaluable reference tool for the bookmaker, publisher, writer, and bookseller. Contains retailers and antiquarians in the United States and Canada; wholesalers of books and magazines in the United States and Canada; book trade information; and indices.

9 American Society of Composers, Authors and Publishers Staff. *ASCAP Copyright Law Symposium*. New York: Columbia University Press, 1989.

10 *Annual Register of Grant Support: A Directory of Funding Sources*. Chicago: Marquis Professional Publications, 1985.

Provides information on the grant

support programs of government agencies, foundations, corporations, unions, educational and professional associations of interest to nonprofit organizations and individuals.

11 *Arts Management: An Annotated Bibliography*, rev. ed. New York: Center for Arts Information, 1980.

"A reference guide to books and other printed materials, organized in six categories: management, planning and program development, fundraising and technical assistance, marketing and public relations, governing boards, and research and public policy."

12 Arth, Marvin and Helen Ashmore. *The Newsletter Editor's Desk Book*. Shawnee Mission, KS: Parkway Press, 1984.

13 *1989 Artist's Market*. Cincinnati, OH: Writer's Digest Books, 1989.

14 *ACUCAA Bulletin: Information and Ideas for Arts Administrators*. Washington, D.C.: Association of College, University, and Community Arts Administrators.

15 *ACUCAA Membership Directory*. Madison, WI: Association of College, University, and Community Arts Administrators, 1985.

16

Audience Development: An Examination of Selected Analysis and Prediction Techniques Applied to Symphony and Theatre Attendance in Four Southern Cities. New York: National Endowment for the Arts Research Division Report, Publishing Center for Cultural Resources, 1984.

"A tool to help groups with audience-building programs."

17

Author Aid/Research Associates International. *Literary Agents of North America, 3rd Edition: The Complete Guide to U.S. and Canadian Literary Agencies.* New York: 1988.

Lists agents by subject, policy, size, geography, and people. Each alpha entry includes name, address, telephone number, year established, CEO, commission percentage, foreign rep, policies, manuscript categories, specialties, comments, and professional affiliations.

18

Authors and Publishers: Agreements and Legal Aspects of Publishing, 2d ed. Butterworth, 1987.

B

19

Baker, Charles Arnold. *Practical Law for Arts Administrators.* United Kingdom: J. Offord, 1983.

20

Balio, Tino. *The American Film Industry*. Madison, WI: University of Wisconsin Press, 1985.

21

Balthaser, William F. *Call for Help: How to Raise Philanthropic Funds with Phonothons*. Ambler, PA: Fund-Raising Institute.

22

Barnhart, Helene Schellenberg. *How to Write & Sell the 8 Easiest Article Types*. Cincinnati, OH: Writer's Digest Books, 1989.

23

Baskerville, David, Ph.D. *Music Business Handbook and Career Guide*, 4th ed. With Foreword by Stan Cornyn. Los Angeles: The Sherwood Company, 1985.

An ASCAP award-winning book dealing with all aspects of the music industry. In six major parts: marketplace, publishing, business affairs, record industry, broadcasting and film, and career planning. The appendices are worth the price of the book alone. Sample forms.

24

Bay Area Lawyers for the Arts. *The Art of Deduction: Income Taxation for Performing, Visual, and Literary Artists*. San Francisco: Bay Area Lawyers for the Arts, 1983.

"Short and clear, with lots of examples. Easy to use."

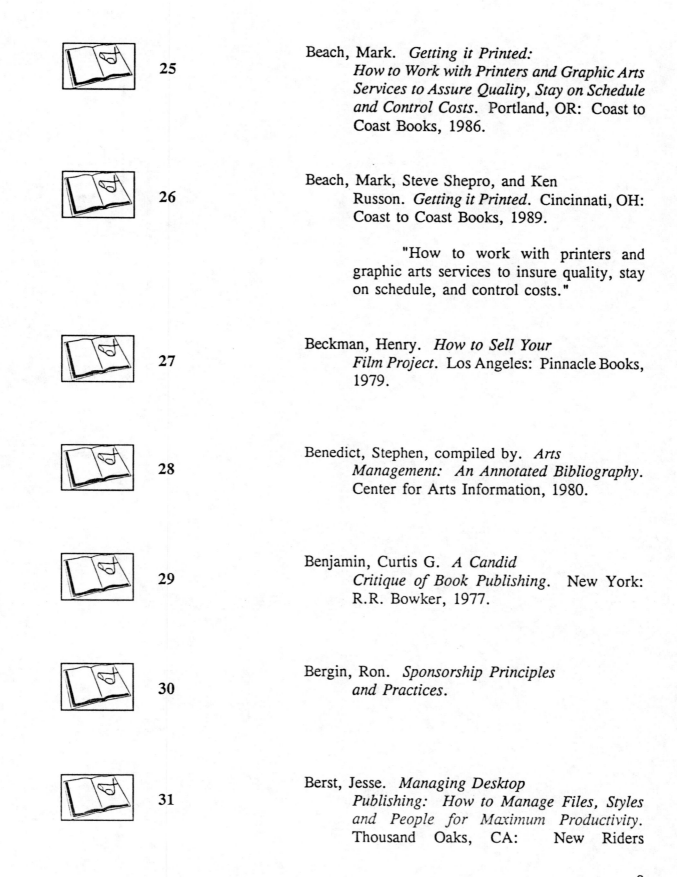

25 Beach, Mark. *Getting it Printed: How to Work with Printers and Graphic Arts Services to Assure Quality, Stay on Schedule and Control Costs*. Portland, OR: Coast to Coast Books, 1986.

26 Beach, Mark, Steve Shepro, and Ken Russon. *Getting it Printed*. Cincinnati, OH: Coast to Coast Books, 1989.

"How to work with printers and graphic arts services to insure quality, stay on schedule, and control costs."

27 Beckman, Henry. *How to Sell Your Film Project*. Los Angeles: Pinnacle Books, 1979.

28 Benedict, Stephen, compiled by. *Arts Management: An Annotated Bibliography*. Center for Arts Information, 1980.

29 Benjamin, Curtis G. *A Candid Critique of Book Publishing*. New York: R.R. Bowker, 1977.

30 Bergin, Ron. *Sponsorship Principles and Practices*.

31 Berst, Jesse. *Managing Desktop Publishing: How to Manage Files, Styles and People for Maximum Productivity*. Thousand Oaks, CA: New Riders

Publishing, 1989.

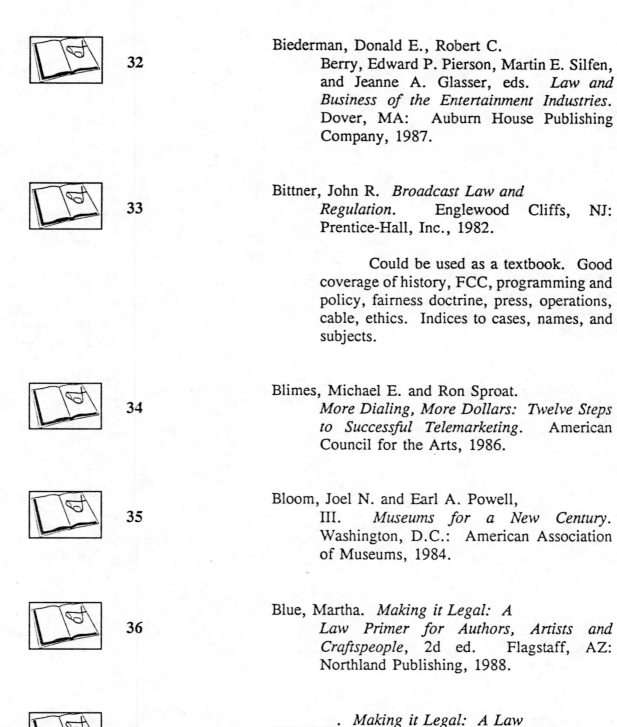

32 Biederman, Donald E., Robert C. Berry, Edward P. Pierson, Martin E. Silfen, and Jeanne A. Glasser, eds. *Law and Business of the Entertainment Industries*. Dover, MA: Auburn House Publishing Company, 1987.

33 Bittner, John R. *Broadcast Law and Regulation*. Englewood Cliffs, NJ: Prentice-Hall, Inc., 1982.

 Could be used as a textbook. Good coverage of history, FCC, programming and policy, fairness doctrine, press, operations, cable, ethics. Indices to cases, names, and subjects.

34 Blimes, Michael E. and Ron Sproat. *More Dialing, More Dollars: Twelve Steps to Successful Telemarketing*. American Council for the Arts, 1986.

35 Bloom, Joel N. and Earl A. Powell, III. *Museums for a New Century*. Washington, D.C.: American Association of Museums, 1984.

36 Blue, Martha. *Making it Legal: A Law Primer for Authors, Artists and Craftspeople*, 2d ed. Flagstaff, AZ: Northland Publishing, 1988.

37 _____. *Making it Legal: A Law Primer for the Craftmaker, Visual Artist, and Writer*, rev. ed. Northland Publishing, 1988.

38

Blum, Richard A. and Richard D. Lindheim. *Primetime: Network Television Programming*. Boston: Focal Press, 1987.

Outlines decision-making strategies and concerns for television programming. Shows how to develop programming team players.

39

Bodian, Nat G. *Bodian's Publishing Desk Reference: A Comprehensive Dictionary of Practices and Techniques for Book and Journal Marketing and Bookselling*. Phoenix: Oryx Press, 1988.

"Almost 4,000 entries provide a comprehensive overview of facts, ideas, techniques, and approaches for workers at all levels of book and journal marketing and bookselling."

40

_____. *Copywriters Handbook: A Practical Guide for Advertising and Promotion of Specialized and Scholarly Books and Journals*. Philadelphia, PA: ISI Press, 1984.

41

Bodian, Nat G. *The Publisher's Direct Mail Handbook*. Philadelphia, PA: ISI Press, 1987.

42

Bone, Jan. *Opportunities in Film*. Lincolnwood, IL: VGM Career Horizons, 1983.

43 Botein, M., et al. *Development and Regulation of New Communication Technologies: Cable Television, Subscription Television, Multipoint Distribution Service and Direct Broadcast Satellites.* Communications Media, 1980.

44 Braham, Bert. *The Graphic Arts Studio Manual.* Cincinnati, OH: North Light Books, 1989.

"This business handbook shows artists how to set up their business; find and work with clients; and develop a wide variety of design concepts and presentation ideas."

45 Braheny, John. *The Craft & Business of Songwriting.* Cincinnati, OH: Writer's Digest Books, 1989.

46 Brakeley, George A. *Tested Ways of Successful Fund Raising.* New York: ANACOM, 1980.

"Details the basic elements of a fundraising campaign from donor motivation and market research to creating and conducting the campaign."

47 Bream, Herbert. *The Business of Book Publishing: Papers by Practitioners.* Boulder, CO: Westview Press, 1985.

48 Brenner, Alfred. *The TV Scriptwriter's Handbook.* Cincinnati, OH: Writer's Digest Books, 1989.

"Where to get ideas, whom to sell and how to sell your script; what a script, an outline, and an idea look like; the role of the producer, editor, network executive, agent; contracts, collaboration, fee structures, and residuals."

49 Bronfeld, Stewart. *How to Produce a Film*. Englewood Cliffs, NJ: Prentice-Hall, 1984.

50 Bruccoli, Matthew J. and Richard Layman, eds. *Contemporary Authors Biographical Series*. Marshalltown, IA: Gale Books, 1989.

"Consult this series for in-depth treatment of the scholarship concerning major contemporary American novelists, poets, and dramatists. For each author covered, *CABS* furnishes a biographical checklist of works by and about the writer, plus an essay describing and evaluating the most significant secondary sources."

51 Bryant, Marija and Todd Bryant. *The Working Photographer: The Complete Manual for the Money-Making Professional*. New York: Avon, 1985.

52 Burack, Sylvia K., ed. *The Writer's Handbook 1989*. Camp Hill, PA: Quality Paperback Books, 1989.

"The guide has an updated list of 2,200 book and magazine publishers that describes their editorial requirements and payment rates. You'll also find lists of representative literary agents, writers'

organizations, contests, awards, and grants for writers."

53 Burton, Gary. *Musicians' Guide to the Road*. Elmhurst, IL: Music Business Publications.

C

54 *Cable Franchising and Regulation: A Local Government Guide to the New Law.* National League Cities, 1985.

55 Caplin, Lee Evans, ed. *The Business of Art*. Englewood, Cliffs, NJ: Prentice-Hall, 1982.

"Relates specifically to visual artists. Useful chapters on promotion and marketing."

56 Carvalio, Robert M. *Photography: What's the Law?* New York: Crown, 1979.

57 Casewit, Curtis W. *Making a Living in the Fine Arts*. New York: MacMillan, 1981.

58

Cavallo, Robert M. and Stuart Kahan. *The Business of Photography.* New York: Crown Publishers, Inc., 1981.

Overview of areas in which one should concentrate on when starting a photography business: business entity, leases, insurance, taxes, accounting, sales, marketing, tools and guilds. Index.

59

_____. *Photography: What's the Law? How the Photographer and the User of Photographs Can Protect Themselves.* New York: Crown Publishers, Inc.

60

Center for Arts Administration. *A Survey of Arts Administration Training 1987-88.* Graduate School of Business, University of Wisconsin-Madison. New York: American Council for the Arts, 1987.

Lists 27 graduate-level arts administration programs, providing program overview, background, orientation, administration, degree requirements, thesis/research paper, internship requirements, and admission procedures. Appendix.

61

Center for Arts Information. *Jobs in the Arts and Arts Administration: A Guide to Placement/Referral Services, Career Counseling, and Employment Listings*, 3d ed. New York: Center for Arts Information, 1981.

62

Chandoha, Walter. *How to Shoot & Sell Animal Photos.* Cincinnati, OH: Writer's Digest Books, 1989.

 63

Clifton, Roger L. *The Road Map to Success: A Unique Development Guide for Small Arts Groups*. 1988.

 64

Cochrane, Diane. *This Business of Art*. New York: Watson-Guptill Publications, 1988.

"Focuses on writers and visual artists. Good for information about contracts, cooperatives, insurance, bookkeeping and taxes."

 65

Coe, Linda, Rebecca Denney, and Anne Rogers. *Cultural Directory II: Federal Funds and Services for the Arts and Humanities*. Washington, D.C.: Smithsonian Institution Press, 1980.

"Includes descriptions of more than 300 federal programs, activities and resources that offer various types of assistance to individuals, institutions, and organizations in the arts and humanities."

 66

Coe, Linda and Stephen Benedict. *Arts Management: An Annotated Bibliography*. Washington, D.C.: National Endowment for the Arts, Cultural Resources Development Project, 1978.

 67

Cohen, Robert. *Acting Professionally, Raw Facts about Careers in Acting*, 3d ed. New York: Barnes & Noble, 1983.

 68

Cok, Mary Van Someren. *All in Order: Information Systems for the Arts.* Washington, D.C.: National Assembly of State Arts Agencies, 1981.

 69

Cole, Barry, ed. *Television Today: A Close-up View.* New York: Oxford University Press, 1981.

A collection of background articles from *TV Guide.* Covers audience, programming, news, effects, censorship and control, public television, and the future.

 70

Coleman, Howard W. *Case Studies in Broadcast Management.* New York: Communications Arts Books, 1978.

 71

Colgan, Betsy and Eleanor Johnson, eds. *1987-88 Directory of Editorial Resources.* Alexandria, VA: Editorial Experts, Inc., 1988.

Excellent resource book for writers and editors, listing trade books and directories, periodicals and professional organizations, training opportunities, and grammar hotline. Index.

 72

Commission on Museums for a New Century. *Museums for a New Century.* Washington, D.C.: American Association of Museums, 1984.

 73

Cone, Arthur Lambert, Jr. *Solid Gold Fund-Raising Letters.* Ambler, PA: Fund-Raising Institute.

 74

Connelly, Will. *Musician's Guide to Independent Record Production.* Elmhurst, IL: Music Business Publications.

 75

Conner, Floyd, et al. *The Artist's Friendly Legal Guide.* Cincinnato, OH: North Light Books, 1988.

 76

Conner, Susan, ed. *1989 Artist's Market: Where & How to Sell Your Artwork.* Cincinnati, OH: North Light Books, 1989.

 "Graphic artists as well as fine artists looking for new marketing opportunities will find 2,500 buyers of all types of art in this new edition -- galleries, magazine/book publishers, advertising agencies, greeting card publishers, audiovisual firms, and art/design studios."

 77

Cool, Lisa Collier. *How to Sell Every Magazine Article You Write.* Cincinnati, OH: Writer's Digest Books, 1989.

 78

Crawford, Robert W. *In Art We Trust: The Board of Trustees in the Performing Arts.* New York: Foundation for the Extension and Development of the American Professional Theatre, 1981.

 As the title suggests, this book concentrates mainly on development of the board of trustees for a performing arts organization. It goes into the purpose and function of the board, as well as how to structure and maintain a board. Sample bylaws are included. Good reference book.

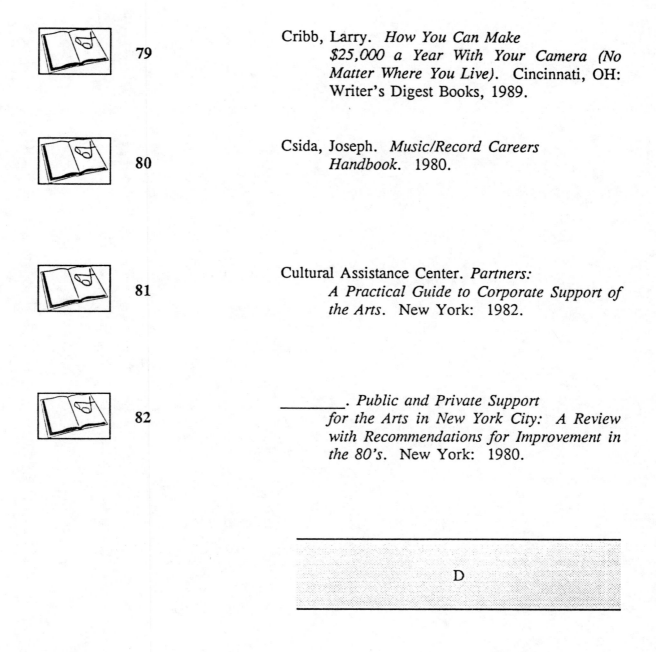

79 Cribb, Larry. *How You Can Make $25,000 a Year With Your Camera (No Matter Where You Live)*. Cincinnati, OH: Writer's Digest Books, 1989.

80 Csida, Joseph. *Music/Record Careers Handbook*. 1980.

81 Cultural Assistance Center. *Partners: A Practical Guide to Corporate Support of the Arts*. New York: 1982.

82 _____. *Public and Private Support for the Arts in New York City: A Review with Recommendations for Improvement in the 80's*. New York: 1980.

D

83 Dagnal, Cynthia. *Starting Your Own Rock Band*. Elmhurst, IL: Music Business Publications.

84 David, Martin A. *The Dancer's Audition Book*. New York: Sterling, 1982.

85 Davidson, Marion and Martha Blue. *Making it Legal: A Law Primer for the Craftmaker, Visual Artist and Writer*. New York: McGraw-Hill, 1979.

 "Especially good information on incorporation. Many sample contracts and agreements."

86 Davis, Mitchell P. *Directory of Experts, Authorities and Spokespersons*. Washington, D.C.: Broadcast Book Division, 1988.

 This directory lists thousands of names, addresses, and phone numbers of industry people who avail themselves for personal interviews. It is geared mainly for the talk show producer.

87 Davis, Sally Prince. *The Graphic Artist's Guide to Marketing and Self-Promotion*. Cincinnati, OH: North Light Books, 1989.

 "The annual directory tells graphic artists where to sell their work. This companion book shows them how to sell through effective publicity and marketing

efforts."

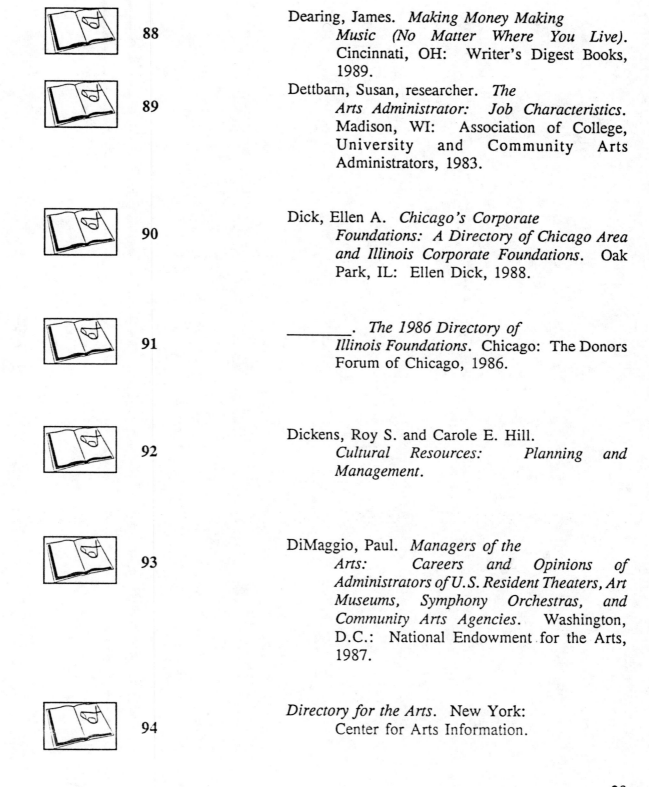

88 Dearing, James. *Making Money Making Music (No Matter Where You Live)*. Cincinnati, OH: Writer's Digest Books, 1989.

89 Dettbarn, Susan, researcher. *The Arts Administrator: Job Characteristics*. Madison, WI: Association of College, University and Community Arts Administrators, 1983.

90 Dick, Ellen A. *Chicago's Corporate Foundations: A Directory of Chicago Area and Illinois Corporate Foundations*. Oak Park, IL: Ellen Dick, 1988.

91 _____. *The 1986 Directory of Illinois Foundations*. Chicago: The Donors Forum of Chicago, 1986.

92 Dickens, Roy S. and Carole E. Hill. *Cultural Resources: Planning and Management*.

93 DiMaggio, Paul. *Managers of the Arts: Careers and Opinions of Administrators of U.S. Resident Theaters, Art Museums, Symphony Orchestras, and Community Arts Agencies*. Washington, D.C.: National Endowment for the Arts, 1987.

94 *Directory for the Arts*. New York: Center for Arts Information.

20

"Detailed descriptions of 145 national and local organizations and government agencies which provide services, programs, and funds for arts organizations, artists, and local sponsors in New York State."

95

Directory of Grants in the Humanities, 1987. Phoenix, AZ: Oryx Press, 1987.

Lists grants by programs, subject index, and sponsoring organizations. Each entry includes grant title, description, restrictions, requirements, subject index, terms, funding amount, application renewal data, and sponsor information.

96

Directory of Matching Gift Programs for the Arts. New York: Business Committee for the Arts, Inc., 1984.

"Contains 255 entries. Each entry includes contact information, defines who may make a matching gift, details the type of match and lists what is eligible and ineligible for a match."

97

Dramatists Sourcebook 1988-89. New York: Theatre Communications Group, 1988.

"More than 700 entries describing script submission policies of over 225 theatres, playwriting contests, publishing outlets, developmental workshops and conferences, service organizations that aid playwrights."

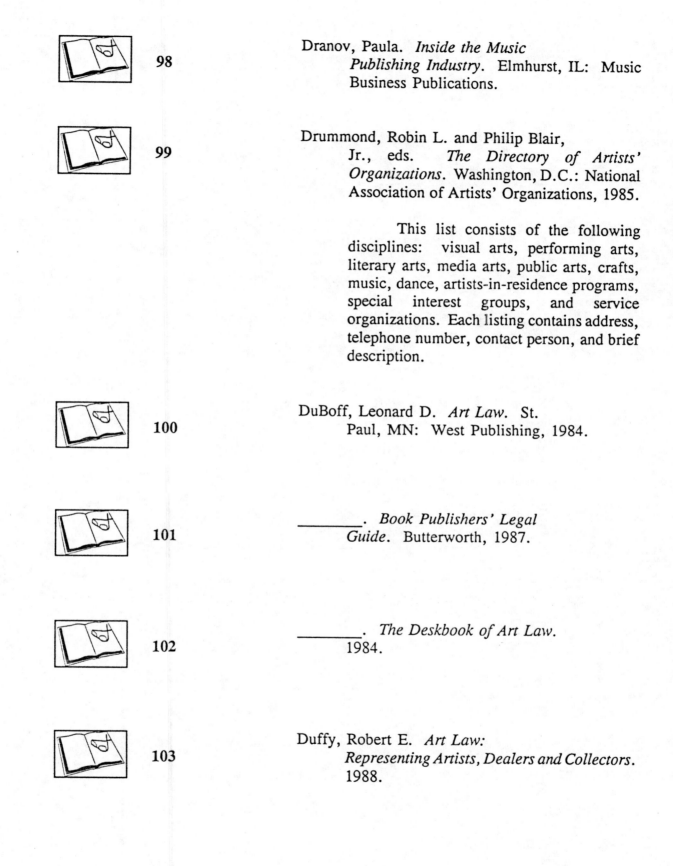

98 Dranov, Paula. *Inside the Music Publishing Industry*. Elmhurst, IL: Music Business Publications.

99 Drummond, Robin L. and Philip Blair, Jr., eds. *The Directory of Artists' Organizations*. Washington, D.C.: National Association of Artists' Organizations, 1985.

This list consists of the following disciplines: visual arts, performing arts, literary arts, media arts, public arts, crafts, music, dance, artists-in-residence programs, special interest groups, and service organizations. Each listing contains address, telephone number, contact person, and brief description.

100 DuBoff, Leonard D. *Art Law*. St. Paul, MN: West Publishing, 1984.

101 _____. *Book Publishers' Legal Guide*. Butterworth, 1987.

102 _____. *The Deskbook of Art Law*. 1984.

103 Duffy, Robert E. *Art Law: Representing Artists, Dealers and Collectors*. 1988.

104

Duke, Judith S. *Religious Publishing and Communications*. White Plains, NY: Knowledge Industry Publications, Inc., 1981.

Analyses the Christian and Jewish publishing markets in the U.S. Contains valuable information relating to demographics, distribution, book clubs, economics, magazine publishing, records and broadcasting. Profiles organizations in religious communications. Appendices, selected bibliography and index.

105

Dumler, Egon and Robert F. Cushman, eds. *The Down Jones-Irwin Handbook for Entertainers and Their Professional Advisors*. Homewood, IL: Down Jones-Irwin, 1987.

106

Dunbar, Ann. *Alice in Arts Administration*. Woodchuck Press, 1986.

107

Duncan, William A. *Looking at Income-Generating Businesses for Small Nonprofit Organizations*. Washington, D.C.: Center for Community Change, 1982.

E

108

Editors of Coda. *The Writing Business: Poets and Writers*. New York, NY: Poets and Writers, Inc., 1985.

109

Eidenier, Connie, ed. *1989 Children's Writer's & Illustrator's Market*. Cincinnati, OH: Writer's Digest Books, 1989.

110

Engh, Rohn. *Sell and Re-Sell Your Photos*, 2d ed. Cincinnati, OH: Writer's Digest Books, 1988.

New edition provides current information, techniques, and tools. Section on computers introduces photographer to their use - databases, word processing, graphics, spreadsheets, and tele-communications. List of markets, tips, bibliography, and index.

111

Entertainment, Publishing, and the Arts Handbook. Clark Boardman.

112

Erickson, J. Gunnar, Edward R. Hearn, and Mark E. Halloran. *Musician's Guide to Copyright*, rev. ed. New York: Scribner & Sons, 1983.

 113

Evarts, Susan. *The Art and Craft of Greeting Cards*. Cincinnati, OH: North Light Books, 1989.

"Shows how to create designs for greeting cards, announcements, and invitations, covering preparing artwork, printing, and marketing."

 114

Ewell, Peter T. *Principles of Program Evaluation for Arts Development*. Springfield, IL: Sangamon Arts Administration Library, Sangamon State University, 1978.

Identifies the need and delineates the steps necessary to properly evaluate a community arts organization. Paper delivered at a seminar on community arts development.

F

 115

Fadel, Nancy A. *The National Directory of Grants & Aid to Individuals in the Arts, International*, 7th ed. DesMoines, IA: Arts Letter, 1989.

"Listing of most grants, prizes, and awards for professional work in the United States and abroad, and information about

universities and schools which offer special aid to students."

116 Farber, Donald C., ed. *Entertainment Industry Contracts: Negotiating and Drafting Guide.* New York: Matthew Bender and Co., Inc., 1986.

This four-volume set is the standard reference tool for the entertainment attorney. Coverage includes book publishing, music, motion pictures, television, and theatre. Not only is this a form book, but it includes expert instructions on negotiating, industry customs, what you should expect, fees, and potential problems encountered. The full set is expensive. It is in looseleaf format and updated as needed. An invaluable collection for any library.

117 Federal Council on the Arts and the Humanities. *Cultural Directory II: Federal Funds and Services for the Arts and Humanities.* Washington, D.C.: Smithsonian Institute Press, 1980.

118 Feldman, Franklin, et al. *Art Law: Rights and Liabilities of Creators and Collectors.* Little, 1986.

119 *Film Service Profiles.* New York: Center for Arts Information.

"Detailed descriptions of 57 national and local organizations and funding agencies which offer services to independent filmmakers and film users in New York State. Fully indexed."

 120 Finchley, Joan. *Audition! A Complete Guide for Actors, with an Annotated Selection of Readings.* Englewood Cliffs, NJ: Prentice-Hall, 1984.

 121 Fink, Conrad C. *Strategic Newspaper Management.* New York: Random House, 1988.

An excellent reference book for newspaper management, written for the teacher, student, and manager. Sticks to the point of management and covers the topic thoroughly. Includes name and subject indices.

 122 Fink, Michael. *Inside the Music Business: Music in Contemporary Life.* New York: Schirmer Books, 1989.

 123 Firestone, Rod and Benjamin Krepack. *Start Me Up! (The Music Biz Meets the Personal Computer).* Van Nuys, CA: Mediac Press, 1985.

 124 Firstenberg, Paul B. *Managing for Profit in the Nonprofit World.* New York: The Foundation Center, 1986.

"The nature of nonprofit organizations, legal, tax, and economic considerations; financial growth, fundraising, commercial income, and endowments; marketing, an undervalued art; critical managerial tools; professionalization of management; board relations, building a partnership."

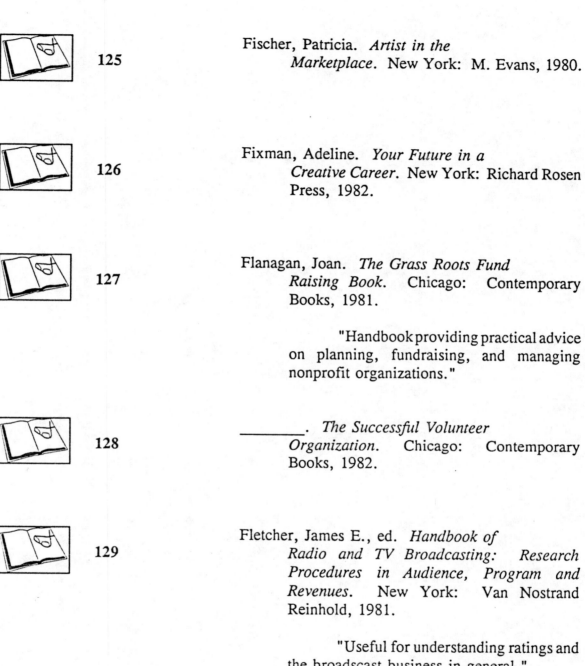

125 Fischer, Patricia. *Artist in the Marketplace*. New York: M. Evans, 1980.

126 Fixman, Adeline. *Your Future in a Creative Career*. New York: Richard Rosen Press, 1982.

127 Flanagan, Joan. *The Grass Roots Fund Raising Book*. Chicago: Contemporary Books, 1981.

"Handbook providing practical advice on planning, fundraising, and managing nonprofit organizations."

128 _____. *The Successful Volunteer Organization*. Chicago: Contemporary Books, 1982.

129 Fletcher, James E., ed. *Handbook of Radio and TV Broadcasting: Research Procedures in Audience, Program and Revenues*. New York: Van Nostrand Reinhold, 1981.

"Useful for understanding ratings and the broadscast business in general."

130 Folke, Ann and Richard Harden. *Opportunities in Theatrical Design and Production*. Lincolnwood, IL: VGM Career Horizons, 1984.

131

The Foundation Directory and Supplement, 11th ed. New York: The Foundation Center, 1988.

"Foundation listings offering new fiscal data, personnel, purpose and activities, giving restrictions, types of support, and application data; and time-saving indices to help target foundations by subject, foundation name, geographic focus, donors', trustees', and officers' names, and types of support."

132

The Foundation Grants Index Annual, 17th ed. New York: The Foundation Center, 1988.

"The largest compilation of foundation grants ever published, with over 43,000 grants of $5,000 or more. Alphabetical, subject, geographic, and recipient category indices."

133

Frascogna, X.M., Jr. and H. Lee Hetherington. *Successful Artist Management*. Elmhurst, IL: Music Business Publications.

134

Fredette, Jean M., ed. *Writer's Digest Handbook of Magazine Article Writing*. Cincinnati, OH: Writer's Digest Books, 1989.

"You'll get practical instruction on finding ideas, research, leads, proposals, and marketing."

135

FRI Prospect-Research Resource Directory, rev. ed. Ambler, PA: Fund-Raising Institute, 1989.

Five indices: name of resource, type of prospect, subject, geographic location, and type of resource.

136

Fujita, S. Neil. *Aim for a Job in Graphic Design.* New York: Richard Rosen Press, 1979.

137

Fulton, Len and Ellen Ferber, eds. *The International Directory of Little Magazines and Small Presses, 1986-87,* 22nd ed. Paradise, CA: Dustbooks, 1986.

138

Fund Raising for Museums: The Essential Book for Staff and Trustees. Bellevue, WA: The Hartman Planning and Development Group, 1985.

"Basic instructions for museum fundraisers, including a directory of foundations, corporations, and government agencies that have funded museums."

G

139

Gadney, Alan. *How to Enter and Win Film Contests.* New York: Facts on File, 1981.

140

Gardner, Richard K. *Library Collections, Their Origins, Selection, and Development*. New York: McGraw-Hill, 1981.

141

Geiser, Elizabeth A., Arnold Dolin and Gladys S. Topkis, eds. *The Business of Book Publishing: Papers by Practitioners*. Boulder, CO: Westview Press, 1985.

Technical, in-depth study of the book publishing industry, told by writing professionals. Three major industry areas - editorial, production, and marketing - are discussed point by point. Some ancedotes, but mostly direct tips. Tables, figures, list of publishers, and index.

142

Georgi, Charlotte. *The Arts and the World of Business: A Selected Bibliography*, 2d ed. Metuchen, NJ: Scarecrow Press, Inc., 1979.

Compiled by the Chief Librarian of the UCLA School of Business Administration, it gives a worthwhile listing of arts-related books from 1960-1979.

143

Gibson, James. *Getting Noticed: A Museum's Guide to Publicity and Self-Promotion*. Cincinnati, OH: Writer's Digest, 1987.

144

_____. *How You Can Make $30,000 a Year as a Musician without a Record Contract*. Cincinnati, OH: Writer's Digest Books, 1989.

145

Gignilliat, William Robert III.
Contracts for Artists. Atlanta, GA: Words of Art, Inc., 1983.

146

Giving U.S.A. New York: American Association of Fund Raising Counsel, 1985.

An annual compilation with numerous tables and graphs illustrating facts and trends in American philanthropy and charitable contributions.

147

Golden, Joseph. *Help! Guide to Seeking, Selecting and Surviving an Arts Consultant*. With an Introduction by William M. Dawson. Illustrated by David Golden. Syracuse, NY: Cultural Resources Council, 1983.

This book appears to be written for the arts organization in need of help. In searching for a consultant, author Golden outlines preparatory work for the arts manager to ready herself for the consultant. Golden suggests the manager should perform tasks from a needs assessment to conducting a market analysis.

148

_____. *On the Dotted Line: The Anatomy of a Contract*. Carol T. Jeschke, ed. Illustrated by David Hicock. New York: Cultural Resources Council, 1979.

This book is geared for the corporate or philanthropic sponsor of an arts organization and/or project. Deals with disclaimers, waivers and general contract components. Appendix and index.

149
Goodale, James C. *All About Cable:
Legal and Business Aspects of Cable and Pay
Television*. New York: Law Journal
Seminars Press, 1988.

A thorough study of the history,
federal and state regulatory practices,
franchising and local regulations of pay cable
and pay television. Presents legal and
business operational aspects of the industry.
Excellent appendices, table of cases, and
index.

150
Goodell, Gregory. *Independent
Feature Film Production: A Complete Guide
from Concept to Distribution*. New York:
St. Martins Press, 1982.

151
Goodloe, Alfred. *Publisher's Guide
to Successful Multinational Mailings*. New
York: Direct International.

152
Goodman, Suzanne Koblentz. *Partners:
A Practical Guide to Corporate Support of
the Arts*. Patricia C. Jones, ed. New York:
Cultural Assistance Center, Inc., 1982.

This report focuses on the relationship
between the corporate giver and the arts
organization. Its aim is to assist corporations
in improving their businesses and
communities through the union with cultural
organizations and, at the same time, guide
the arts organization toward corporate
fulfillment.

153
Goodwin, John R. *Legal Primer for
Artists and Crafts Persons*. Publication
Horizons, 1986.

154

Gordon, Barbara. *Opportunities in Commercial Art and Graphic Design.* Lincolnwood, IL: VGM Career Horizons, 1985.

155

Gordon, Barbara and Elliot. *How to Survive in the Free-Lance Jungle: A Realistic Plan for Success in Commercial Art and Photography.* New York: Executive Communications, 1980.

156

Goss, Frederick. *Success in Newsletter Publishing: A Practical Guide,* 3d ed. Arlington, VA: The Newsletter Association, 1988.

Covers most, if not all, aspects of the newsletter publishing business. Includes current technologies, formulas for success, as well as thoughtful tips on strategic planning and implementation. Glossary, bibliography, and index.

157

Grant Proposals that Succeeded. Ambler, PA: Fund-Raising Institute.

"This is a library of carefully selected, successful proposals for grants. Word for word as they were submitted."

158

Grants for Arts & Cultural Programs. New York: The Foundation Center, 1988.

"Detailed listings of some 4,500 grants of $5,000 or more made to cultural institutions."

159 *Grants for Film, Media and Communications*. New York: The Foundation Center, 1988.

160 *Grants for Museums*. New York: The Foundation Center, 1988.

161 Graphic Artist's Guild. *Handbook of Pricing and Ethical Guidelines*, 6th ed. Cincinnati, OH: North Light Books, 1989.

"This book provides both graphic artists and their clients with current pricing methods and professional business practices applied throughout the industry."

162 Green, Laura R., ed. *Money for Artists: A Guide to Grants and Awards for Individual Artists*. New York: American Council for the Arts, 1987.

Categories include literary, media, multidisciplinary, performing, and visual arts. Indices broken down by state, discipline, organization, and award.

163 Greenberg, Jan Weingarten. *Theater Business: From Auditions through Opening Night*. New York: Holt, Rinehart and Winston, 1981.

164 _____. *Theater Careers: A Comprehensive Guide to Non-Acting Careers in the Theater*. New York: Holt, Rinehart and Winston, 1983.

165 Greenwood, Walter, ed. *McNae's Essential Law for Journalists*, 9th ed. United Kingdom: Butterworth, 1985.

166 Gregory, J. Reed. *This Business of Entertainment and its Secrets*. Detroit: National Publishing Co., 1985.

167 *Guide to Corporate Giving 3*. New York: American Council for the Arts, 1983.

168 Gurin, Maurice G. *What Volunteers Should Know for Successful Fund Raising*. New York: Stein and Day, 1981.

H

169 Hall, Mary. *Getting Funded: A Complete Guide to Proposal Writing*, 3d ed. Portland, OR: Continuing Education Publications, Portland State University, 1988.

An essential book for every fundraiser's library. "Step-by-step guidance from idea to finished proposal. Inside tips and strategies based on winning proposals. More information on foundation and corporate funding sources. Added resource

lists, cases, models, checklists, and sample formats." Excellent.

170 Hamburg, Morton I. *All About Cable: Legal and Business Aspects of Cable and Pay Television*. New York: Law Publishing, 1981.

171 Hample, Henry S. *For More Information: A Guide to Arts Management Information Centers*. New York: Center for Arts Information, 1986.

172 *The Handbook of Magazine Publishing*, 2d ed. New Canaan, CT: Folio Publishing Corp., 1983.

A great step-by-step guide to magazine publishing. Includes advertising, marketing, circulation management, promotion, single-copy sales, fulfillment, editorial, graphics, production, printing, and management. A must for any new start-up.

173 Hanson, Nancy Edmonds. *How You Can Make $25,000 a Year Writing (No Matter Where You Live)*. Cincinnati, OH: Writer's Digest Books, 1989.

174 Harris, Herby and Lucien Farrar. *How to Make Money in Music: A Guidebook for Success in Today's Music Business*. New York: Arco Publishing, 1978.

175 Hartman, Hedy H. *Fund Raising for Museums*. Bellevue, WA: Hartman Planning and Development Group, 1985.

"A looseleaf workbook on museum fund-raising, with appendices on funding sources for museums."

 176 Henderson, Bill, ed. *The Art of Literary Publishing: Editors on Their Craft*. Yonkers, NY: The Pushcart Press, 1980.

Insightful study of literary publishing. Anecdotes told by those whose lives are their profession - editors. Interesting and thought-provoking reading.

 177 Hendon, William S., et al, eds. *Economic Policy for the Arts*. Abt Books, 1980.

 178 Henry, Austin H. and E. Arthur Prieve. *Improved Financial Management of Smaller Performing Arts Organizations*. Madison, WI: Center for Arts Administration, Graduate School of Business, University of Wisconsin-Madison, 1973.

 179 Henry, Laurie, ed. *1989 Novel & Short Story Writer's Market*. Cincinnati, OH: Writer's Digest Books, 1989.

 180 Herbert, Ian, ed. *Who's Who in the Theatre*, 17th ed. Marshalltown, IA: Gale Books, 1981.

"Contains 2,200 biographical entries for actors, actresses, directors, playwrights, and other figures of the English-speaking

stage."

181 Hihenberg, John. *The Professional Journalist*, 5th ed. New York: Holt, Rinehart, and Winston, 1983.

182 Hirsch, E. G. *Copyright it Yourself.* Collage Inc., 1979.

183 Hodes, Scott. *Legal Rights in the Art and Collectors' World*, 2d ed. Oceana, 1986.

184 Holden, Donald. *Art Career Guide.* New York: Watson-Guptill, 1983.

185 Hoover, Deborah, A. *Supporting Yourself as an Artist: A Practical Guide.* New York: Oxford University Press, 1985.

 This book is for the individual entrepreneurial artist. Gives general overview of areas of concern for the business of art. Contains glossary, bibliography, and index.

186 Horn, Maurice, ed. *Contemporary Graphic Artists*. Marshalltown, IA: 1986.

 "Consult this series for biographical

and career information on a wide range of contemporary graphic artists, including illustrators, animators, cartoonists, designers, and others whose work appears in books, newspapers, magazines, film, and other media. Volumes are profusely illustrated, with each entry including a portrait of the artist and one or more examples of artist's work. Lengthy sketches put the work of individual artists in perspective, and many sketches include comments by the artists themselves."

187

Horwitz, Tem, ed. *Law and the Arts--Art and the Law.* Chicago: Lawyers for the Creative Arts, 1979.

"Excellent chapters relating to legal problems of performing and visual artists, film and video makers; financial planning; and budgeting.

188

How to Find Philanthropic Prospects. Ambler, PA: Fund-Raising Institute.

"Shows exactly how to locate and evaluate prospective donors of any kind: individuals, corporations, foundations, associations, or governments. Teaches you how to launch, run, and expand a profitable prospect-research program." Forms.

189

Hubbard, Linda S. and Owen O'Donnell, eds. *Contemporary Theatre, Film, and Television.* Marshalltown, IA: Gale Books, 1989.

"Use this series to find biographical and career information on currently popular individuals active in theatre, film, and

television, including: performers, directors, writers, producers, designers, managers, choreographers, technicians, composers, executives, dancers, critics."

190

Hudson, Howard Penn. *Publishing Newsletters: A Complete Guide to Markets, Editorial Content, Design, Subscriptions, Management, and Desktop* Publishing, rev. ed. New York: Macmillan Publishing Company, 1988.

A how-to book featuring current technological industry applications. Discusses market analysis, management, styling and designing, production, subscription drives, and printing processes. Glossary, bibliography, and index.

191

Hyman, Richard. *Professional Artist's Manual.* New York: VanNostrand, Reinhold, 1980.

I

192

Illinois Media '87/'88: The Comprehensive Directory of all Print and Electronic Media in Illinois. Chicago: Midwest Newsclip, Inc., 1987.

Great listing of print and electronic media resources: national wire services, Chicago, suburban, and Illinois newspapers, radio, television and cable. Lists deadlines, frequency, editors, names, addresses and telephone numbers.

193

In Art We Trust: The Board of Trustees in the Performing Arts. New York: Foundation for the Extension and Development of the American Professional Theatre, 1981.

194

International Directory of Arts, 1989-90, 19th ed. Marshalltown, IA: Gale Books, 1989.

"This contemporary guide to art sources and markets in 137 countries contains over 130,000 names and addresses, including working artists, individual collectors, art dealers and galleries, art museums, and more."

195

International Literary Market Place, 1988-89. New York: R.R. Bowker, 1988.

A necessity for any publisher marketing books internationally. Lists 160 countries, breaking down publishers, booksellers, libraries, organizations, associations, agents, clubs, and calendar of events.

196

International Who's Who in Music and Musicians' Directory, 11th ed. Marshalltown, IA: Gale Books, 1988.

"The main portion of the fully revised and updated new edition contains approximately 10,000 biographical entries. The directory covers almost all countries and represents a wide variety of musical interests. Additional material includes data on orchestras, musical organizations, competitions, music libraries, and colleges and other educational establishments."

 197 Istel, John, ed. *Theatre Directory 1987-88.* New York: Theatre Communications Group, 1987.

"Provides complete contact information for nearly 300 nonprofit professional theatres and related arts organizations across the United States. Contains key personnel, theatre addresses, business and box office phone numbers, performance seasons and dates, Actors' Equity Association contract information, complete information on 41 arts resource organizations, and a regional index, listing theatres by state."

 198 _____. *Theatre Profiles 8: The Illustrated Guide to America's Nonprofit Professional Theatres.* New York: Theatre Communications Group, 1988.

"Resource that provides comprehensive information on more than 200 theatre companies nationwide. Packed with vital information, this title provides a statement of purpose from each theatre's artistic director, and production histories from the 1985-86 and 1986-87 seasons, listing play, playwright, director and designers for each play. Also included are production photos, names of artistic and managerial heads, telephone numbers,

addresses, founding dates, performing seasons, seating capacities and types of stages, operating expenses, and union contracts. Appendices include a complete name and title index, chronology of founding dates, and a listing by region."

199

Jacobs, Lou Jr., revised and updated. *Selling Photographs: Determine Your Rates and Understand Your Rights*. New York: Amphoto, 1988.

Thoroughly describes work categories of professional photography and what it takes to capture the market. Includes separate forms. Useful resource for the pro. Index, appendix and book list.

200

Jacques Cattell Press, ed. *American Book Trade Directory, 35th Edition*. New York: R.R. Bowker Company, 1988.

An industry standard that lists North American retailers, wholesalers and statistical information on book and magazine selling. Each category entry includes: name of business, address, SAN, telephone number, key personnel, import/export information, types of accounts, types of books, subject specialties, and ownership. Listed by city and state.

201

Jankowski, Katherine E., ed. *Corporate Giving Yellow Pages: Taft Guide to Corporate Giving Contacts*, 6th ed. Washington, D.C.: The Taft Group, 1989.

"Over 2,650 corporate direct giving programs and company-sponsored foundations."

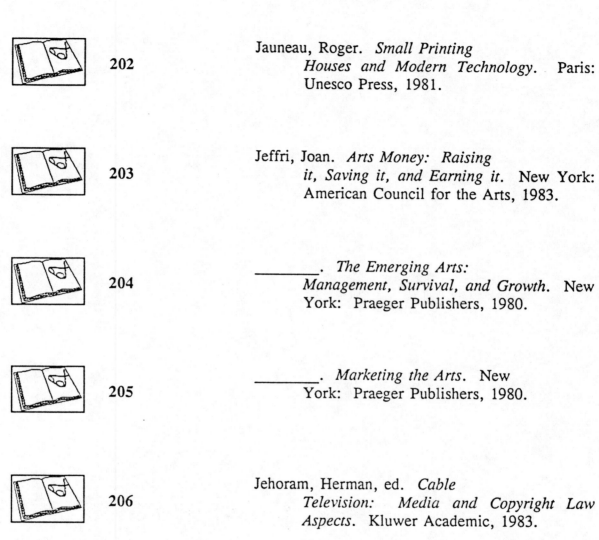

202 Jauneau, Roger. *Small Printing Houses and Modern Technology.* Paris: Unesco Press, 1981.

203 Jeffri, Joan. *Arts Money: Raising it, Saving it, and Earning it.* New York: American Council for the Arts, 1983.

204 _____. *The Emerging Arts: Management, Survival, and Growth.* New York: Praeger Publishers, 1980.

205 _____. *Marketing the Arts.* New York: Praeger Publishers, 1980.

206 Jehoram, Herman, ed. *Cable Television: Media and Copyright Law Aspects.* Kluwer Academic, 1983.

207 Jerome, Judson. *1989 Poet's Market: Where & How to Publish Your Poetry.* Cincinnati, OH: Writer's Digest Books, 1988.

"Complete contact details for and critiques of each of the 1,700 poetry publishers, 550 of which are brand new listings."

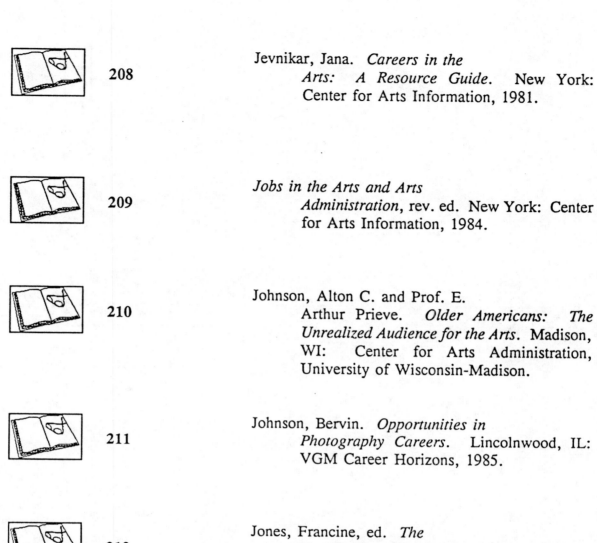

208 Jevnikar, Jana. *Careers in the Arts: A Resource Guide*. New York: Center for Arts Information, 1981.

209 *Jobs in the Arts and Arts Administration*, rev. ed. New York: Center for Arts Information, 1984.

210 Johnson, Alton C. and Prof. E. Arthur Prieve. *Older Americans: The Unrealized Audience for the Arts*. Madison, WI: Center for Arts Administration, University of Wisconsin-Madison.

211 Johnson, Bervin. *Opportunities in Photography Careers*. Lincolnwood, IL: VGM Career Horizons, 1985.

212 Jones, Francine, ed. *The Foundation Center Source Book Profiles*. New York: The Foundation Center, 1989.

213 Jones, Swan Lois. *Art Research Methods and Resources:* A Guide to Finding Art Information. Dubuque, IA: Kendall/Hunt, 1984.

214

Kaderlan, Norman Stanley. *The Arts Administrator: The Nature of the Role and its Organizational Environment*. Madison, WI: Center for Arts Administration, University of Wisconsin-Madison, 1981.

An interesting study on the new (1971) area called arts administration. The author's dissertation is a thorough analysis of the application of behavoral sciences to arts organizations. It includes in-depth statistical analyses, as well as numerous tables and charts.

215

Kalish, Susan E., Tara McCallum, Yvette Henry, Arnold Schoenthaler, and Sheila Grady, eds. *The Proposal Writer's Swipe File: 15 Winning Fundraising Proposals ... Prototypes of Approaches, Styles, & Structures*. Washington, D.C.: Taft Corporation, 1984.

216

Keen, Sherman. *Practical Techniques for the Recording Engineer*. Elmhurst, IL: Music Business Publications.

217

Keith, Michael. *Radio Programming: Consultancy and Formats*. Washington, D.C.: Broadcast Book Division, 1987.

This book analyzes how programming decisions are made, covering targeting audience and major formats. Bibliography and index.

218 Keith, Michael and Joseph Krause.
The Radio Station. Washington, D.C.: Broadcast Book Division, 1986.

This book gets deep into commercial radio. It talks about management, programming, promotion, news, sales, engineering, and production. Includes sample forms, glossary, and index.

219 *The Key to Effective Trusteeship of Arts Organizations: The Board Chairman and His Challenge*. University Park, PA: Pennsylvania State University, 1976.

220 King, George V. *Deferred Gifts: How to Get Them*. Ambler, PA: Fund-Raising Institute.

"It's a non-technical book that emphasizes the practical, promotional, and managerial aspects of deferred giving. Reviewed by legal counsel, it's applicable to virtually any type of organization."

221 Kiritz, Norton J. *Program Planning and Proposal Writing*. Los Angeles: The Grantsmanship Center, 1980.

"An extremely well-written and helpful guide to writing program proposals."

222 Kirkpatrick, D.L., ed.
Contemporary Dramatists, 4th ed. Marshalltown, IA: Gale Books, 1988.

223

Koller, Fred. *How to Pitch and Promote Your Songs.* Cincinnati, OH: Writer's Digest Books, 1988.

"How to set up a business plan to achieve your goals: getting started, running a business, planning to succeed, publishing, and pitching your demo."

224

Kopelman, Arie and Tad Crawford. *Selling Your Photography: The Complete Marketing, Business, and Legal Guide.* New York: St. Martin's Press, 1980.

Brief overview of the photographic industry in three sections: marketing, business, and legal. Index, list of books, periodicals, and professional organizations. Marketing section deals mainly within New York.

225

Kozak, Ellen M. *Every Writer's Practical Guide to Copyright: Fifty Questions and Answers.* Inkling Publications, 1985.

226

Kremer, John. *Book Marketing Made Easier.* Fairfield, IA: Ad-Lib Publications, 1986.

Every form and consideration for book marketing is spelled out in a step-by-step approach. Budgetary, editorial, publicity, exhibition, and distribution are among the detailed categories. Excellent forms and bibliography.

227

_____. *Directory of Short-Run Book Printers*, 3d ed. Fairfield, IA: Ad-Lib Publications, 1985.

Excellent listing of book manufacturers and printers specializing in low quantity print runs. Offers tips on the trade.

228

Krol, John, ed. *Gale Directory of Broadcast Media and Personnel.* Marshalltown, IA: Gale Books, 1989.

"An annual guide to radio stations, television stations, and cable television companies and systems in the United States and Canada."

229

Kuniholm, Roland E. *Maximum Gifts by Return Mail: An Expert Tells How to Write Highly Profitable Fund-Raising Letters.* Ambler, PA: Fund-Raising Institute, 1989.

230

Kurzig, Carol. *Foundation Grants to Individuals.* New York: The Foundation Center, 1984.

"Foundations which provide assistance to individuals are profiled by the type of grant awarded."

L

231

LaBlanc, Michael L., ed.
 Contemporary Musicians. Marshalltown, IA:
 Gale Books, 1989.

 "Biographical and critical guide to
performers and writers in a wide variety of
musical fields, including pop, rock, jazz,
rhythm and blues, folk, new age, country,
gospel, and reggae. About 80-100 musicians
are covered in each volume."

232

Lane, Marc J. *Legal Handbook for
 Nonprofit Organizations.* New York:
 AMACOM, 1980.

233

Langley, Stephen. *Theatre
 Management in America, Principle and
 Practice*, 2d rev. ed. New York: Drama
 Book Specialists, 1980.

 Bible for any new theatre manager
and/or theatre manage-ment major. It
contains helpful background information,
both historically and practically, on all forms
of American theatre. The nuts and bolts of
the book are reflected in the last half, which
outlines the economics of theatre operation
and audience development. The appendices
are illustrative examples of necessary forms
and outlines. Contains a sample limited
partnership offering for a fictitious play.
Bibliography and index.

234

Langley, Stephen and James Abruzzo.
 *Jobs in Arts and Media Management: What
 They Are and How to Get One!* New York:
 Drama Book Publishers, 1986.

 This is a career guide for the future
arts manager. After describing how the

profession evolved, the authors give advise on career planning and list arts management graduate internship and apprenticeship programs.

235

Lee, Spike. *Do the Right Thing.*
New York: Simon and Schuster, Inc., 1989.

236

_____. *Spike Lee's Gotta Have It: Inside Guerrilla Film-making.* New York: Simon and Schuster, Inc., 1987.

Through the author's personal journal, he describes how he raised $175,000 to produce the award-winning film "She's Gotta Have It". Includes film's script.

237

Lee, Spike and Lisa Jones.
Foreword by Ossie Davis. *Uplift the Race: The Construction of School Daze.* New York: Simon and Schuster, Inc., 1988.

In anecdotal form, Lee describes the intricacies of producing his film "School Daze".

238

Lefferts, Robert. *Getting a Grant in the 1980s: How to Write Successful Grant Proposals.* New Jersey: Prentice-Hall, 1982.

239

Legal and Business Aspects of Book Publishing, 1988. PLI, 1988.

240

Leland, Caryn R. *The Art Law Primer*. New York: Foundation for the Community of Artists, 1981.

"Short, good articles on print commission contracts, negotiations of commission agreements, artist/museum loan agreements, sales agreements, leases and hiring representatives."

241

Lewis, M.K. and Rosemary. *Your Film Acting Career: How to Break into the Movie and TV Business and Survive in Hollywood*. New York: Crown, 1983.

242

Lidstone, Herrick. *Tax Guide for Artists and Art Organizations*. Lexington, MA: Lexington Books, 1979.

243

Lindey, Alexander. *Lindey on Entertainment, Publishing and the Arts: Agreement and the Law*, 2d ed. New York: Clark Boardman Co., Ltd., 1988.

Great compilation of forms and descriptions of legal issues affecting the industry. Includes index to forms. Three volume set. Excellent reference tool.

244

Livingston, Robert Allen. *Livingston's Complete Music Industry Business and Law Reference Book*. Cardiff by the Sea, CA: GLGLC Music, 1981.

This work is an expanded glossary/dictionary of business terms commonly used in the music business. Some definitions are more noteworthy than others.

245 _____. *Music Attorney Directory*. Cardiff by the Sea, CA: GLGLC Music, 1986.

246 Logan, Tom. *Acting in the Million Dollar Minute: The Art and Business of Performing in TV Commercials*. Washington, D.C.: Communications Press, 1984.

247 _____. *How to Act and Eat at the Same Time: The Business of Landing a Professional Acting Job*. Washington, D.C.: Communications Press, 1982.

248 London, Mel. *Making it in Film: An Insider's Guide to Succeeding in the Film Industry*. New York: Simon and Schuster, 1985.

249 Loney, Glenn Meredith. *Creating Careers in Music Theatre*. New York: P. Lang, 1988.

250 Lower, Robert C. and Jeffrey E. Young. *An Artist's Handbook on Copyright*. Georgia V Law, 1981.

251 Lowry, W. McNeil. *The Arts and Public Policy in the United States*. Englewood Cliffs, NJ: Prentice-Hall, 1984.

252

Lyon, Christopher, ed.
International Dictionary of Films and Filmmakers. Marshalltown, IA: Gale Books, 1988.

"Four volumes provide detailed reference material on films, directors/filmmakers, actors and actresses, and writers and production artists with an index volume completing the set. Coverage is world wide and focuses on individuals that have shaped the history of the film."

M

253

MacIntyre, Kate. *Sold Out: A Publicity and Marketing Guide*. New York: Theatre Development Fund, 1980.

"A reference guide to publicity and promotion in the arts."

254

Malaro, Marie C. *A Legal Primer on Managing Museum Collections*. Washington, D.C.: Smithsonian, 1985.

"Covers issues that bear on collection management and that may arise in relation to the acquisition and disposal of objects, loans, appraisals, tax considerations, insurance, and visitor and employee safety."

255 Mann, Jim. *Solving Publishing's Toughest Problems*. Folio, 1982.

256 Martin, George, ed. *Making Music: The Guide to Writing, Performing, and Recording*. Elmhurst, IL: Music Business Publications.

257 May, Hal and Susan Trosky, eds. *Contemporary Authors*, vol. 126. Marshalltown, IA: Gale Books, 1989.

> "Here's where you can find biographical, career, and publication information for architects, artists, astrologers, biographers, cartoonists, explorers, jazz artists, religious figures, sports figures, newspaper and television reporters and correspondents, columnists, editors, photojournalists, screenwriters, television scriptwriters, and other media people."

258 McCavitt, William E. and Peter K. Pringle. *Electronic Media Management*. Washington, D.C.: Broadcast Book Division, 1986.

> New technologies and declining audiences are studied in this comprehensive handbook for electronic media managers. The book has an exhaustive bibliography, chapter highlights and useful appendices. The reader gets 340 pages of the workings and concerns to managers.

259 McCutcheon, Pricilla and Karen Tecott. *Developing Older Audiences: Guidelines for Performing Arts Groups.* 1985.

260 McKenzie, Alan. *How to Draw and Sell Comic Strips.* Cincinnati, OH: North Light Books, 1989.

261 McLeish, Robert. *The Technique of Radio Production*, 2d ed. Washington, D.C.: Broadcasting Book Division, 1988.

"This updated edition details production methods used in the typical radio studio, including proper use of the mixing desk and other equipment. Covers a wide range of programming, discussing scriptwriting, interviewing and live commentary, newsreading and presentation, recording music, producing drama, and creating commercials. Glossary and bibliography."

262 McNeil, Barbara, ed. *Artist Biographies Master Index.* Marshalltown, IA: Gale Books, 1986.

"For those needing to find biographical information on a wide range of artists, this new biographical index contains over 275,000 citations to biographical sketches of artists appearing in about 70 titles. Coverage includes illustrators, fine artists, architects, photographers, the decorative arts, and folk artists."

263
Melillo, Joseph V., ed. *Market the Arts!* New York: Foundation for the Extension and Development of the American Professional Theatre, 1983.

"An anthology with contributions by arts professionals on developing effective marketing techniques."

264
Menen, Aubrey. *Art and Money*. New York: McGraw-Hill Book Company, 1980.

265
Metzger, Linda, Hal May, Deborah A. Straub, and Susan M. Trosky, eds. *Black Writers*. Marshalltown, IA: Gale Books, 1989.

Includes personal data, career data, writings, work in progress, sidelights, and biographical/critical sources of more than 400 Twentieth Century writers, from the Harlem Renaissance, social and political activists, and foreign black writers of interest.

266
Miller, Fred. *Studio Recording for Musicians*.

267
Miller, Peter and Janet Nelson. *The Photographer's Almanac*. Boston: Little, Brown and Company, 1983.

Background book for the budding professional photographer.

 268 Millsaps, Daniel. *National Directory of Arts and Education Support by Business Corporations, 2.* Washington, D.C.: Washington International Arts Letter, 1982.

 269 _____. *National Directory of Arts Support by Private Foundations,* vol. 4. Washington, D.C.: Washington International Arts Letter, 1980.

 270 _____. *National Directory of Grants and Aid to Individuals in the Arts.* Washington, D.C.: Washington International Arts Letter, 1983.

"Listings of grants, prizes, and awards for professional artists in the United States and abroad and information about universities and schools which offer special aid to students."

 271 Mitchell, Arnold. *The Professional Performing Arts: Attendance Patterns, Preferences and Motives*, vols. 1 & 2. Madison, WI: Association of College, University and Community Arts Administrators, 1984 and 1985.

"A key study relating lifestyles and values to arts attendance."

 272 Mokwa, Michael P., William M. Dawson and E. Arthur Prieve, eds. *Marketing the Arts.* New York: Praeger, 1980.

273

Monaco, Bob and James Riordan. *The Platinum Rainbow*. Elmhurst, IL: Music Business Publications.

274

Monoff, Robert Karl. *The Buck Starts Here*. New York: Volunteer Lawyers for the Arts, 1985.

"Transcript of a Volunteer Lawyers for the Arts 1983 conference on profit-making ventures for nonprofit groups."

275

Mooney, Michael M. *The Ministry of Culture: Connections Among Art, Money and Politics*. New York: Wyndham Books, 1980.

276

Moore, Dick. *Opportunities in Acting Careers*. Lincolnwood, IL: VGM Career Horizons, 1985.

277

Moore, Lou and Nancy Kassak, eds. *Computers and the Performing Arts*. New York: Theatre Communications Group, 1980.

278

Morison, Bradley G. and Julie Gordon Dalgleish. *Waiting in the Wings: A Larger Audience for the Arts and How to Develop it*. New York: American Council for the Arts, 1987.

Broken down into 3 acts: Act 1, the past, deals briefly with arts management in the embryonic stages of the 1930s, as told through situational vignettes. Act 2, the

present, concentrates on the concepts of audience development as currently implemented. Act 3, the future, suggests ways for improving earned income. Included are simple, yet useful formulas for computing future attendance.

N

279

National Association of
Broadcasters Legal Guide. National Association of Broadcasters.

280

National Databook. New York: The Foundation Center, 1984.

Provides name, address, and contact information for all currently active grant-making foundations in the United States. Listed by state, with a separate alphabetical name index.

281

National Research Center of the
Arts, Inc. *Americans and the Arts: A 1984 Survey of Public Opinion Conducted for Philip Morris, Inc.*, 1984.

Focuses primarily on performing arts, changes, and crises. Majority of study contained in the appendices: tables, surveying methods, and questionnaire development.

282

The National Society of Fund
Raising Executives. *Getting Started: A Guide to Fund Raising Fundamentals.* Westmont, IL: National Society of Fund Raising Executives.

283

Navaretta, Cynthia. *Guide to Women's Art Organizations and Directory for the Arts: Multi-Arts Centers, Organizations, Galleries, Groups, Activities, Networks, Publications, Archives, Slide Registries.* New York: Midmarch Associates, 1982.

284

Naylor, Colin, ed. *Contemporary Artists*, 3d ed. Marshalltown, IA: Gale Books, 1989.

"Entries include a biography, list of exhibitions, galleries and museums, bibliography, statement by the artist, and a photograph of a representative work."

285

_____. *Contemporary Photographers*, 2d ed. Marshalltown, IA: Gale Books, 1988.

"Providing detailed information on some 750 photographers of international reputation, this work covers living photographers, as well as those from earlier in the century who continue to exert an influence today."

286 Nelson, Charles A. and Frederick J. Turk. *Financial Management for the Arts: A Guidebook for Arts Organizations*. New York: Associated Councils of the Arts, 1975.

287 Nelson, George. *The Death of Rhythm and Blues*. New York: Pantheon Books, 1988.

Well-researched book about the rise and fall of rhythm and blues, as well as the management styles of the recording companies and artists of this era.

288 Nelson, Roy Paul. *Publication Design*, 4th ed. Dubuque, IA: W.C. Brown, 1987.

289 Newman, Danny. *Subscribe Now! Building Arts Audiences Through Dynamic Subscription Promotion*. New York: Theatre Communications Group, 1988.

290 Nielsen, Eric Brandt. *Dance Auditions: Preparation, Presentation, Career Planning*. 1984.

291

O'Connell, Brian. *Effective Leadership in Voluntary Organizations.* New York: Walker and Co., 1981.

"A guide to nonprofit management, planning, and fundraising."

292

O'Donnell, Lewis B., Carl Hausman, and Philip Benoit. *Announcing: Broadcast Communicating Today.* Belmont, CA: Wadsworth Publishing Company, 1987.

An excellent technical reference, highlighting the ins and outs of broadcast announcing. Covers voice skills, copy marking, radio and television, interviewing, commercials, and acting techniques. Appendices, index, glossary, and reading list.

293

Orabona, B. Nadine. *The Photographer's Computer Handbook.* Cincinnati: Writer's Digest Books, 1984.

Gives background information on computer hardware and software; then introduces the photographer to the many ways in which the computer can help manage the business. Describes applications and highlights what to look for when purchasing a system. Touches on telecommunications. Glossary and index.

294

Osborne, Alfred E. *Economics of the Performing Arts: A Bibliography*. Los Angeles: Graduate School of Management, University of California-Los Angeles, 1976.

295

Owens, Bill. *Publish Your Photo Book: A Guide to Self-Publishing*. Livermore, CA: Owens, 1979.

P

296

Page, Gillian, Robert Campbell, and Jack Meadows. *Journal Publishing: Principles and Practice*. London: Butterworth and Co., Ltd., 1987.

"Comprehensive account of how to create, maintain, and develop journals." Includes chapters on editing, production, and marketing, as well as fulfillment and distribution, and legal and financial considerations. Appendices, bibliography, and index.

297

Papolos, Janice. *The Performing Artist's Handbook*. Cincinnati, OH: Writer's Digest Books, 1989.

"This book prepares you for the realities of the classical music business and

presents frank, accurate information on the self-promotion techniques and know-how you need."

298

Peacock, James. *How to Audition for Television Commercials and Get Them*. Chicago: Contemporary Books, 1982.

299

People in Philanthropy. Washington, D.C.: The Taft Corporation, 1984.

 Biographical data on current major donors, foundation and corporate officials, and trustees.

300

Peterson, Linda, ed. *Annual Register of Grant Support 1989*. Wilmette, IL: National Register Publishing Company, 1989.

301

1989 Photographer's Market: Where & How to Sell Your Photographs. Cincinnati, OH: Writer's Digest Books, 1988.

 "Complete stock photo listings section and 500 brand new listings."

302

Pick, John. *Arts Administration*. London: E. & F./N. Spon, 1980.

303 Piscopo, Maria. *The Photographer's Guide to Marketing and Self-Promotion.* Cincinnati: Writer's Digest Books, 1987.

Human profiles dominate chapter subjects. Included also are tips, such as, creating a market survey, approaching the media, writing press releases, networking, developing/writing the marketing plan, and using photo reps. Well-focused on the photographic industry.

304 *Planning and Control Guides and Forms for Small Book Publishers.* Bedford, MA: The Huenefeld Company, Inc., 1980.

305 Plasko, George. *Developing a Two-Year Operational Plan for Chamber Music Ensembles.* New York: Chamber Music America, 1981.

306 Pollack, Bruce, ed. *Popular Music,* vol. 12. Marshalltown, IA: Gale Books, 1988.

"American popular music up-to-date through the end of 1987 by providing information on some 400 popular songs of the year, 1987. The annual publication schedule for new volumes allows for inclusion of more songs per year, and entries now include greater detail concerning writers' inspirations, uses of songs, album appearances, etc."

307 Porter, Robert, ed. *Arts Advocacy: A Citizen Action Manual.* New York: American Council for the Arts, 1980.

Offers tips on developing advocacy campaigns for arts organizations. Uses case studies on selected governmental advocacy programs.

308

_____. *A Guide to Corporate Giving in the Arts - 3.* New York: American Council for the Arts, 1983.

"Includes information on the giving policies of over 700 major corporations. Well indexed."

309

_____. *United Arts Fundraising 1984.* New York: American Council for the Arts, 1985.

Great show of how the United Arts Funds secure and allocate resources to arts organizations. Shows actual analyses, formulas, and spreadsheets on how the money is spent.

310

Porter, Robert, ed. and Ellen Stodolsky, ed. dir. *Community Arts Agencies: A Handbook and Guide.* New York: American Council for the Arts, 1978.

Describes arts council structure, management, fund-raising, programs and services, and marketing. Appendices.

311

Poynter, Dan and Charles Kent. *Publishing Contracts: Sample Agreements for Book Publishers on Disk.* Para Publishing, 1987.

312

Prieve, E. Arthur and Daniel J. Schmidt. *Administration in the Arts: An Annotated Bibliography of Selected References*. Madison, WI: Center for Arts Administration, Graduate School of Business, University of Wisconsin-Madison, 1977.

Begins with section on books to help arrange personnel and the board of directors. Lists books on financial management, marketing the arts, and arts in society. The majority of the books are general business books.

313

Procedure Manual for Cataloging Photographs. Tuscon, AZ: Center for Creative Photography.

314

Proceedings 6th Symposium on Small Computers in the Arts. Philadelphia: Small Computers in the Arts Network, Inc., 1986.

Compiled as a result of a networking meeting. Overview of computer uses in design, television, publishing, and animation.

315

Professional Business Practices in Photography, 4th ed. New York: American Society of Magazine Photographers, 1986.

To be used by the professional photographer with questions concerning assignment photography, stock pictures, form agreements, copyright protection, technology, insurance, book publishing, and membership. Includes sample forms and index. A must for the pro.

*Programming and Distribution in the
 New Video Marketplace.* Chicago, IL:
American Bar Association, 1989.

316

The Proposal Writer's Swipe File.
 Washington, D.C.: Taft Corporation, 1984.

317

 "Includes 15 proposals demonstrating
various approaches, styles, and structures."

*Publisher's Weekly Yearbook: News,
 Analyses and Trends.* New York: R.R.
Bowker, 1989.

318

R

Rachlin, Harvey. *Encyclopedia of
 the Music Business.* Elmhurst, IL: Music
Business Publications.

319

_____. *The Songwriter's and
Musician's Guide to Making Great Demos.*
Cincinnati, OH: Writer's Digest Books,
1988.

320

 "Comprehensive book on recording
demos, covering multi-track recording and
MIDI, plus exactly how to submit demos for
best results."

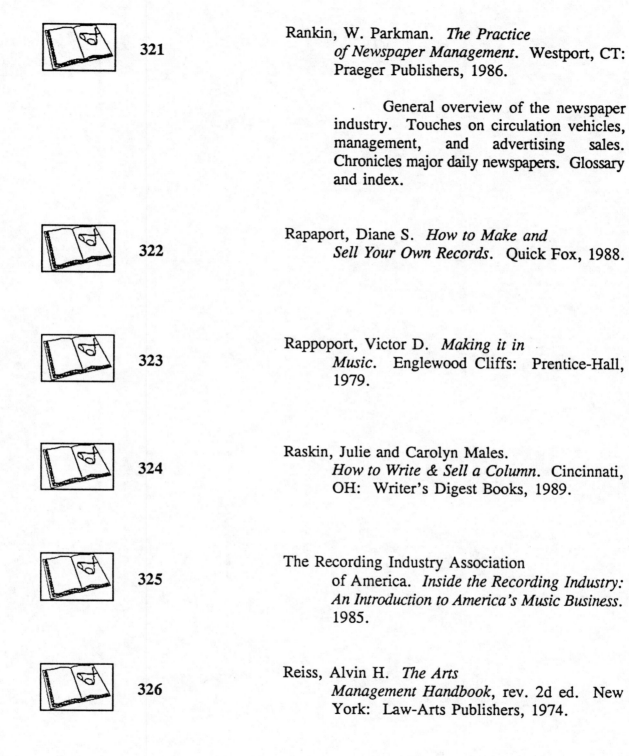

321 Rankin, W. Parkman. *The Practice of Newspaper Management*. Westport, CT: Praeger Publishers, 1986.

General overview of the newspaper industry. Touches on circulation vehicles, management, and advertising sales. Chronicles major daily newspapers. Glossary and index.

322 Rapaport, Diane S. *How to Make and Sell Your Own Records*. Quick Fox, 1988.

323 Rappoport, Victor D. *Making it in Music*. Englewood Cliffs: Prentice-Hall, 1979.

324 Raskin, Julie and Carolyn Males. *How to Write & Sell a Column*. Cincinnati, OH: Writer's Digest Books, 1989.

325 The Recording Industry Association of America. *Inside the Recording Industry: An Introduction to America's Music Business*. 1985.

326 Reiss, Alvin H. *The Arts Management Handbook*, rev. 2d ed. New York: Law-Arts Publishers, 1974.

327

_____. *The Arts Management Reader*. New York: Audience Arts, 1979.

Key study of organization, operations and communications, funding, government, business, audiences, public relations, education, and society. Includes recommended reading and index.

328

_____. *Cash In! Funding and Promoting the Arts*. Illustrated by Henry R. Martin. New York: Theatre Communications Group, 1986.

Focuses primarily on developing an identity for your performing arts organization. Offers a variety of promotional strategies. Earned income is expanded to include unusual, yet program-related activities.

329

Renz, Loren, ed. and Stan Olson, assist. ed. *The Foundation Directory*, 11th ed. New York: The Foundation Center, 1987.

330

Richards, Pamela Spence. *Marketing Books and Journals to Western Europe*. Phoenix, AZ: The Oryx Press, 1985.

Resource for the European market. Offers valuable tips on identifying and tapping into the Western European book trade. Highlights selling foreign rights, co-publishing, subsidiaries, export sales agencies, European stockholding booksellers, and journal selling. Appendices and subject index.

331 Riordan, James. *Making it in the
New Music Business*. Cincinnati, OH:
Writer's Digest Books, 1989.

332 Roberts, Ellen E.M. *The Children's
Picture Book: How to Write it, How to Sell
it*. Cincinnati, OH: Writer's Digest Books,
1989.

333 _____. *Nonfiction for Children:
How to Write it, How to Sell it*. Cincinnati,
OH: Writer's Digest Books, 1988.

334 Robertson, Geoffrey and Andrew
Nicol. *Media Law: The Rights of
Journalists, Broadcasters, and Publishers*.
London, England: Sage Publications, 1986.

335 Roosevelt, Rita K., Anita M.
Granoff, and Karen P.K. Kennedy. *Money
Business: Grants and Awards for Creative
Artists*, rev. ed. Boston: The Artists
Foundation, Inc., 1982.

"Resource book of financial assistance
available to creative artists including poets,
fiction writers, playwrights, filmmakers,
video artists, composers, choreographers,
painters, printmakers, sculptors, craftsmen,
and photographers. Describes the grants,
awards, or prizes offered by organizations.
Index.

336 Rosen, Frederick W. *The
Professional Photographer's Business Guide*.
New York: Amphoto, 1985.

337　Ross, Marilyn Heimberg. *How to Make Big Profits Publishing City and Regional Books: A Guide for Entrepreneurs, Writers and Publishers*. Saguache, CO: Communication Creativity, 1987.

338　Ross, Tom and Marilyn Ross. *The Complete Guide to Self-Publishing*, rev. ed. Cincinnati, OH: Writer's Digest Books, 1989.

"Includes current information on desktop publishing, guidelines for business and production matters, actual samples of forms, sales letters, copyright applications, and much more."

339　Runstein, Robert E. and David Miles Huber. *Modern Recording Techniques*, 2d ed. Indianapolis: Howard W. Sams, 1986.

 340

Sanders, Norman. *Photographing for Publications*. New York: R.R. Bowker and Co.

"An examination of the best methods for achieving print excellence for publication."

 341

Sanjek, Russell. *American Popular Music and its Business: The First Four Hundred Years*. New York: Oxford University Press, 1988.

 342

Schneiter, Paul H. *The Art of Asking*. Ambler, PA: Fund-Raising Institute.

 343

Schulberg, Bob. *Radio Advertising: The Authoritative Handbook*. Washington, D.C.: Broadcasting Book Division, 1988.

"Includes such topics as the fair price for advertising time, the effects of TV on radio advertising, barter, and more. Charts, tables, appendix listing essential resources, index, and foreword."

 344

Schwarz, Ted. *The Business Side of Photography*, rev. ed. New York: Amphoto, 1979.

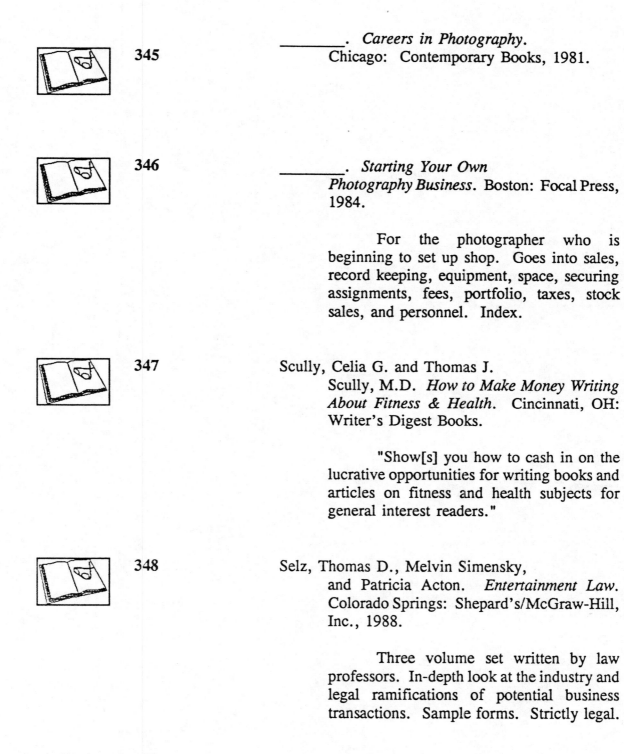

345 _____. *Careers in Photography.* Chicago: Contemporary Books, 1981.

346 _____. *Starting Your Own Photography Business.* Boston: Focal Press, 1984.

For the photographer who is beginning to set up shop. Goes into sales, record keeping, equipment, space, securing assignments, fees, portfolio, taxes, stock sales, and personnel. Index.

347 Scully, Celia G. and Thomas J. Scully, M.D. *How to Make Money Writing About Fitness & Health.* Cincinnati, OH: Writer's Digest Books.

"Show[s] you how to cash in on the lucrative opportunities for writing books and articles on fitness and health subjects for general interest readers."

348 Selz, Thomas D., Melvin Simensky, and Patricia Acton. *Entertainment Law.* Colorado Springs: Shepard's/McGraw-Hill, Inc., 1988.

Three volume set written by law professors. In-depth look at the industry and legal ramifications of potential business transactions. Sample forms. Strictly legal.

349 Seymour, Harold J. *Si Seymour's*

Designs for Fund-Raising, 2d ed. Ambler, PA: Fund-Raising Institute, 1989.

"The giving and soliciting processes; planning, running, and following up a campaign; running a development office; special fund-raising programs; when, why, and how to use a consultant; working with volunteer leadership."

350

Shagan, Rena. *The Road Show: A Handbook for Successful Booking and Touring in the Performing Arts*. Illustrated by Blair Thornley. New York: American Council for the Arts, 1985.

The author is a professional booking agent who has condensed years of experience into this informative book. The reader is instructed on the minute details of organizing a road show, both in the U.S. and abroad. Lists the necessities from the presenter's and artist's points of view. Budgets are discussed, as well as promotional materials. Appendices are invaluable, including sample contracts, resources and a technical information questionnaire.

351

Shanks, Bob. *The Primal Screen: How to Write, Sell, and Produce Movies for Television*. New York: Ballantine Books, 1986.

352

Shemel, Sidney and M. William Krasilovsky. *More About this Business of Music*, rev. 4th ed. New York: Billboard Books, 1989.

"A practical guide to six areas of the music business not treated by *This Business of Music*: serious music, jazz music,

religious music, live performances, production and sale of printed music, and background music and transcriptions." Economic facts deemed significant for daily operations, as well as common legal concepts which guide business decisions are presented.

353

————. *This Business of Music*, rev. 5th ed. New York: Billboard Publications, 1985.

The 5th edition was updated and enlarged in 1987 to primarily reflect the changes brought about by The Tax Reform Act of 1986. Written in four parts, this industry authority discusses every phase of recording companies and artists, music publishers and writers, and general music industry aspects. Extensive appendices, forms, and index.

354

Shore, Harvey. *Arts Administration and Management: A Guide for Arts Administrators and Their Staffs*. New York: Quorum Books, 1987.

An overview of arts management: planning, organizing, staffing, leadership, and control. Glossary, bibliography, and full index.

355

Siegel, Alan. *Breaking into the Music Business*. Elmhurst, IL: Music Business Publications.

356

Simensky, Melvin and Thomas D. Selz. *Entertainment Law*. New York: Matthew Bender, 1984.

A law book that contains case law, sample individual agreements, collective bargaining agreements, and newspaper and magazine articles describing the day-to-day activities within the entertainment industry.

357 Singleton, Ralph S. *Movie Production and Budget Forms Instantly: Professional Filmmaking Forms Ready to be Photocopied*. Beverly Hills, CA: Lone Eagle Publishing, 1985.

358 Sitarz, Daniel. *The Desktop Publisher's Legal Handbook*. Nova Publications, 1989.

359 Sladek, Frea. *Grant Budgeting and Finance*. New York: Plenum Press, 1981.

"A comprehensive guide to preparing and managing your grant proposal budget."

360 Smith, K. *Marketing for Small Publishers*. Turoe Press, 1981.

361 Smith, Mitchell B. *Arts Administration Compensation: 1978 Survey*. New York: American Council for the Arts, 1980.

362 *1990 Songwriter's Market: Where and How to Market Your Songs*. Cincinnati, OH: Writer's Digest Books, 1989.

"Find out where and how to market your songs with updated listings of music publishers, record companies, booking agents, and more -- 650 of which are brand new."

363 *Source Book Profiles*. New York: The Foundation Center, 1985.

"Descriptions of the 1,000 largest American foundations, with each profile updated every two years."

364 Standera, Oldrich. *The Electronic Era of Publishing: An Overview of Concepts, Technologies and Methods*. New York: Elsevier Science Publishing Co., Inc., 1987.

An overview of how computer technologies can be best utilized in the publishing industry. Highlights on-line retrieval process, typesetting methods, document delivery, artificial intelligence, and printing conventions. Includes references, appendices, glossary, list of organizations, and index.

365 Stein, Howard and Ronald Zalkind. *Promoting Rock Concerts*. New York: Shirmer.

366 Stein, Ira C. *Cable Television: Handbook and Forms*. Shepards McGraw.

367

Stockwell, John and Bert Holtje, eds. *The Photographer's Business Handbook: How to Start, Finance, and Manage a Profitable Photography Business.* New York: McGraw-Hill, 1980.

368

Straczynski, J. Michael. *The Complete Book of Scriptwriting.* Cincinnati, OH: Writer's Digest Books.

"Gives complete information on writing scripts for TV, radio, film, and theatre, including the rewards and pitfalls, working relationships, mechanics, and marketing. Features include sample scripts, glossaries of terms, and lists of agents, producers, and studios."

369

Strong, William S. *The Copyright Book: A Practical Guide*, 2d rev. ed. Cambridge, MA: MIT Press, 1984.

"Lengthy but well written. One of the few books about copyright that discusses the problems of media artists."

370

Suber, Charles. *1986 Guide to Business-of-Music Schools & Careers.* Chicago: Charles Suber & Associates, 1986.

Book lists 256 college-level schools in the United States and Canada offering up to 71 curriculum courses related to the business of music and music careers. The schools are categorized by state and each entry identifies name, address, grade level, academic terms, curriculum, enrollment, housing, tuition, financial aid, faculty, and contact person. Business of music careers include music education, performance careers, and non-performing careers. Job titles and expected

salary ranges. Includes professional trade, and music-related governmental organizations. Suggested readings.

371

Survey of Arts Administration Training, 1987-88. New York: American Council for the Arts, 1988.

Lists 27 accredited graduate arts administration programs. Each entry includes background, orientation, and purpose, administration, degree requirements, thesis or major paper requirement, internship requirement, and admission procedure.

372

Surveying Your Arts Audience. New York: Publishing Center for Cultural Resources, National Endowment for the Arts, 1985.

Geared for the performing arts and museum institutions. The objective of the book is to show the reader how to identify audience needs and desires by gathering information by one of three methods: personal interviews, telephone interviews, and written questionnaires, focusing on the latter. Distribution, evaluation, and data calculation are discussed. Sample surveys in the appendix include audience motivation, marketing/pricing, audience demographics, audience satisfaction, and assessment of facilities.

373

Szela, Eva. *The Complete Guide to Greeting Card Design & Illustration.* Cincinnati, OH: North Light Books, 1989.

"This former Hallmark design manager shows how to create, execute, and sell designs for every greeting card style and

subject, using a variety of media and techniques."

T

374

Thomas, Bill. *How You Can Make $50,000 a Year as a Nature Photojournalist.* Cincinnati, OH: Writer's Digest Books.

"A practical guide to all the ways you can make money from nature photography, including how to put words and pictures together into picture stories, photo documentaries, and illustrated articles to increase your chances of a sale."

375

Thomas, Thomas J. and Theresa R. Clifford. *The Public Radio Legal Handbook: A Guide to FCC Rules and Regulations.* National Federal Commission Broadcast, 1986.

376

Thomson, Ross and Bill Hewison. *How to Draw and Sell Cartoons.* Cincinnati, OH: North Light Books, 1989.

"This book shows how to create every type of cartoon -- from political to the simply funny -- with advice on developing a style, series, and strips."

377

Thorne, Robert and Viera, John David, and Stephen F. Briemer, eds. *1989 Entertainment, Publishing and the Arts Handbook*. New York: Clark Boardman Co., 1989.

378

Thurston, Ellen. *Management Assistance for the Arts: A Survey of Programs*. New York: Center for Arts Information, 1980.

Profiles 29 national organizations that assist non-profit cultural and arts groups. Includes training programs, consultant services, on-the-job training, purpose, and management-related publications and periodicals.

379

Tobler and Grund. *The Record Producers*.

380

Trenbeth, Richard P. *The Membership Mystique*. Ambler, PA: Fund-Raising Institute, 1986.

"A detailed examination of virtually every aspect of launching and maintaining a successful membership program."

381

Truskot, Joseph, Anita Belofsky, and Karen Kittilstad, eds. *Principles of Orchestra Management*, 3d ed. Washington, D.C.: American Symthony Orchestra League, 1984.

382

Turk, Frederick J. and Robert P. Gallo. *Financial Management Strategies for the Arts Organizations*. New York: American Council for the Arts, 1984.

Though not a textbook, Turk and Gallo offer sound case study and advise on areas in which arts managers should be concerned--fiscal accountability. Basic accounting formulas and calculations are presented.

U

383

Unwin, Stanley. *The Truth About Publishing*, 8th ed. Chicago: Academy Chicago, 1982.

384

Urban Innovations Group School of Architecture and Urban Planning, University of California, Los Angeles. *The Arts in the Economic Life of the City*. New York: American Council for the Arts, 1979.

Case study approach, primarily using Los Angeles. Focuses on increasing audiences, organizational structuring and planning, and government procurement. Performing, visual, crafts, architecture, and literature.

V

385

VanHorn, James. *The Community Orchestra: A Handbook for Conductors, Managers, and Boards.* Westport, CT: Greenwood Press, 1979.

386

Vincent, Bob. *"Show-Business" is Two Words.* Studio City, CA: Main Track Publications, 1979.

387

Vinter, Robert D. and Rhea K. Kish. *Budgeting for Not-for-Profit Organizations.* New York: The Free Press, 1984.

"Directed at program managers as a guide to the budgeting and fiscal processes common to small and midsize non-profit organizations."

388

Visual Artist's Manual: A Practical Guide to Your Career. Garden City, NY: Doubleday, 1984.

389

Voegeli, Thomas J. *Handbook for Tour Management.* Madison, WI: Center for Arts Administration, Graduate School

of Business, University of Wisconsin-Madison, 1975.

 390
Vogel, Frederick B. *No Quick Fix (Planning)*. New York: Foundation for the Extension and Development of the American Professional Theatre, 1985.

A rare book on such an important subject--a subject arts organizations do too little of--planning. Vogel has mapped out a step-by-step approach to the process. He presents the necessary tools, documents, resources, and methods. Glossary.

 391
Volunteer Lawyers for the Arts and Barbara S. Taylor. *Pressing Business: An Organizational Manual for Independent Publishers*. Volunteer Lawyers for the Arts, 1984.

 392
Volunteer Lawyers for the Arts Staff. *To Be or Not to Be: An Artist's Guide to Not-for-Profit Incorporation*. Volunteer Lawyers for the Arts, 1986.

W

393 Wasko, Janet. *Movies and Money*. Norwood, NJ: Ablex, 1982.

394 Wehle, Mary M. *Financial Practice for Performing Arts Companies: A Manual*. Cambridge, MA: Arts Administration Research Institute, 1977.

395 Weil, Stephen E. *Beauty and the Beasts: On Museums, Art, the Law, and the Market*. Washington, D.C.: Smithsonian, 1983.

396 Weiner, David, ed. *The Video Source Book*, 10th ed. Marshalltown, IA: Gale Books, 1989.

"Provides details on over 54,000 video titles available on tape and/or disc from over 1,250 sources. A wide range of subject matter suitable for all audiences is represented, with access facilitated by a detailed subject index containing over 400 subject categories. Entries furnish up to 18 points of information about each title, including availability, running time, audience rating, intended use, etc. Indices."

397 Weinstein, David A. *How to Protect Your Creative Work: All you Need to Know about Copyright*. Wiley, 1987.

398 Weissman, Dick. *Songwriters' Handy Guide*. Elmhurst, IL: Music Business Publications.

399

Westbrooks, Logan and Lance
Williams. *Anatomy of a Record Company.*
Los Angeles: Westbrooks, 1981.

400

White, Bart and N. Doyle
Satterthwaite. *But First These Messages...The Selling of Broadcast Advertising.* Washington, D.C.: Broadcasting Book Division, 1989.

"Step-by-step guide for salespeople that takes them through the process from researching prospects to 'cementing' the sale. Along the way the authors discuss ratings and rates, selling against and with other media, promotions and co-op advertising, regulation, and other topics. The book provides a comprehensive overview of the tough field of sales in electronic media--radio, TV, and cable."

401

White, David R., Mindy N. Livine, and Kathy Spahn. *Poor Dancer's Almanac: A Survival Manual for Choreographers, Managers, and Dancers.* New York: Dance Theatre Workshop, 1983.

402

White, Hooper. *How to Produce Effective TV Commercials*, 2d ed. Washington, D.C.: Broadcasting Book Division, 1986.

"This authoritative and practical handbook outlines the essential steps in producing an effective TV commercial. It describes how the agency's idea is translated into scripts and storyboards, as well as how to prepare for the presentation. Stresses cost control and preproduction planning. Covers the entire process from selecting a production

company to final editing, detailing the responsibilities of director, cameraman, producer, script clerk, and makeup artist. Illustrations, sample forms, index."

403

White, Virginia P. *Grants for the Arts*. New York: Plenum Press, 1980.

"An excellent book written primarily for arts administrators. Useful as a general reference book for artists."

404

Wiese, Michael. *Film & Video Budgets*. Studio City, CA: Michael Wiese Productions, 1988.

"A basic 'how-to' budget guide for many types of films and videos. Clearly written, informal in style, and generously illustrated with detailed budgets."

405

_____. *Film & Video Marketing*. Studio City, CA: Michael Wiese Productions, 1989.

"A comprehensive guide to film and video marketing and distribution techniques for low budget features and home video programs. Includes developing hit ideas, selling the buyer, market research, getting to your audience, getting distributors, marketing and promotion, packaging and key art, publicity and advertising, specialized markets, release strategies, and a marketing case study of the film "Dirty Dancing".

406

_____. *Home Video: Producing for the Home Market*. Studio City, CA: Michael Wiese Productions, 1986.

"A clear, comprehensive book that brings together advice on the successful development and distribution of original home video programs. Genres such as comedy, how-to, documentaries, children's, sponsored, and music videos are discussed in detail. The book examines new marketing opportunities."

407

_____. *The Independent Film and Videomakers Guide*, 7th ed. Studio City, CA: Michael Wiese Film Productions, 1989.

408

_____. *The Independent Filmmaker's Guide: How to Finance, Produce and Distribute Your Short and Documentary Films*, rev. ed. Studio City, CA: Michael Wiese Film Productions, 1986.

"A classic bestseller and independent producer's best friend. Advice on limited partnerships, writing a prospectus, market research, negotiating, film markets, pay TV, and home video buyers."

409

Williams, Herbert Lee. *Newspaper Organization and Management*, 5th ed. Ames, IA: Iowa State University Press, 1978.

This textbook, originally written in 1955, serves as a guide to cost saving, efficient work flow, and better production within the newspaper industry. Though the sections on production and equipment are a little outdated, the author's approach to total newspaper management is timeless. Financial, organizational, and legal issues are covered in depth, as well as public relations.

410 Williams, M. Jane. *Capital Ideas: How to Solicit Major Gifts from Private Sources*. Ambler, PA: Fund-Raising Institute.

411 _____. *Foundation Primer*, 4th ed. Ambler, PA: Fund-Raising Institute, 1981.

"How to create a master plan, determine staff size and budget, find and use connections, pinpoint your most profitable foundation prospects, and create projects that foundations will like."

412 Williams, Raymond M. *The Business of Education for Retail Music Stores*. Carlsbad, CA: National Association of Music Merchants, 1983.

413 Willis, Jerry. *Guide to Arts Administration Publications and Organizations*. Madison, WI: Association of College, University and Community Arts Administrsators, 1979.

A listing of arts administration-related books, periodicals, annuals, and organizations.

414 Wolseley, Roland and Isabel. *The Journalist's Bookshelf: An Annotated and Selected Bibliography of U.S. Print Journalism*, 8th ed., 1986.

415

1990 Writer's Market: Where and How to Sell What You Write. Cincinnati, OH: Writer's Digest Books, 1989.

"Target your publication efforts with the widest selection of markets for freelance material. 85% of the listings contain new information, and 600 brand new listings have been added."

X

416

Xerox Publishing Standards: A Manual of Style and Design. New York: Watson-Guptill Publications, 1988.

Thorough coverage of the publishing industry. Xerox has set standards for the publishing process, document organization, writing and style, and visual design, in an attempt to establish consistency in printed materials. Book is detail and technical oriented. Appendices, glossary, bibliography, index, figures, and tables.

417 Zeller, Susan L. *Your Career in Radio and Television Broadcasting*. New York: Arco, 1982.

418 Zettl, Herbert. *Television Production Handbook*, 4th ed. Washington, D.C.: Broadcasting Book Division, 1984.

Instructs professionals on studio cameras, lenses, lighting, audio, digital equipment, editing, and post production. Classic reference resource, containing over 900 photographs and illustrations.

419 Zobel, Louise Purwin. *The Travel Writer's Handbook*. Cincinnati, OH: Writer's Digest Books.

"Earn money from your travels with this veteran travel writer's advice on getting background information, taking salable photos, doing on-site research -- even tips on what to pack, plus chapters on freebies, tax benefits, and how to sell to U.S. and foreign markets."

SUBJECT INDEX

Academy of Motion Picture
Arts and Sciences
9849 Wilshire Blvd.
Beverly Hills, CA 90211
(213) 278-8990

Actors Equity Association
203 N. Wabash Avenue
Chicago, IL 60601
(312) 641-0393

Actors Equity Association
165 West 46th Street
New York, NY 10036
(212) 869-8530

Actors Working for an Actors Guild
12842 Hortense Street
Studio City, CA 91604
(818) 506-6672

Alliance of Motion Picture and TV Producers
14144 Ventura Blvd.
Sherman Oaks, CA 91423
(818) 995-3600

American Communications Association
Communications Trade Division
111 Broadway
New York, NY 10006

American Federation of Film Societies
Three Washington Square Village
New York, NY 10012
(212) 254-8688

American Federation of Musicians of the
United States and Canada (AFofM)
1501 Broadway
New York, NY 10036
(212) 896-1330

American Federation of Television and Radio
Artists (AFTRA)
260 Madison Avenue
New York, NY 10016
(212) 532-0800

American Film Institute
John F. Kennedy Center for the Performing
Arts
Washington, D.C. 20566
(202) 828-4000

American Film Marketing Association
10000 Washington Blvd., #5266
Culver City, CA 90232

American Guild of Music
5354 Washington Street
Downers Grove, IL 60515
(312) 968-0173

American Guild of
Musical Artists (AGMA)
1727 Broadway
New York, NY 10019
(212) 265-3687

American Guild of Variety Artists (AGVA)
184 Fifth Avenue
New York, NY 10010
(212) 675-1003

American Institute of Graphic Arts
1059 Third Avenue
New York, NY 10021
(212) 752-0813

American Library Association (ALA)
50 East Huron Street
Chicago, IL 60611
(312) 944-6780

American Music Center (AMC)
250 West 54th Street
New York, NY 10019
(212) 247-3121

American Music Scholarship Association
1826 Carew Tower, Dept. 00516
Cincinnati, OH 45263
(513) 421-5342

American Musicians Union (AMU)
Eight Tobin Court
Dumont, NJ 07628
(201) 384-5378

American Musicological Society
University of Pennsylvania
201 South 34th Street
Philadelphia, PA 19104
(215) 898-8698

American Record Producers Association
952 E. 13th Street
Brooklyn, NY 11230

American Society for Music Copyists
1697 Broadway
New York, NY 10019
(212) 586-2140

American Society of Cinematographers
1782 N. Orange Drive
Hollywood, CA 90028
(213) 876-5080

American Women in Radio and Television
1101 Connecticut Avenue, NW
Washington, D.C. 20036
(202) 429-5102

Amusement and Music Operators Association
2000 Spring Road
Oak Brook, IL 60521
(312) 654-2662

Arts and Business Council (ABC)
130 East 40th Street
New York, NY 10016
(212) 683-5555

Associated Actors and Artistes of America
165 W. 46th Street
New York, NY 10036

Association for the Advancement of Creative
Musicians (AACM)
7058 S. Chappel
Chicago, IL 60649

Association of Black Motion Picture and
Television Producers
c/o Leroy Robinson
Chocolate Chip Productions
6515 Sunset Blvd., Suite 206
Los Angeles, CA 90028

Association of College, University and Community Arts Administrators (ACUCAA)
P.O. Box 2137
Madison, WI 53701
(608) 262-0004

Association of Independent Video and Filmmakers
625 Broadway, 9th Floor
New York, NY 10012
(212) 473-3400

Association of Performing Arts Presenters
1112 16th St., N.W. #620
Washington, D.C. 20036
(202) 833-2787

Association of Talent Agents
9255 Sunset Blvd., Suite 318
Los Angeles, CA 90069
(213) 274-0628

Association of Theatrical
Press Agents and Managers
165 W. 46th Street
New York, NY 10036
(212) 719-3666

Black American Cinema Society
3617 Monclair Street
Los Angeles, CA 90018
(213) 737-3929

Black Filmmaker Foundation
80 Eighth Avenue, Suite 1704
New York, NY 10011
(212) 924-1198

Black Filmmakers Hall of Fame
1221 Broadway, Suite 340
Oakland, CA 94612
(415) 465-0804

Business Committee for the Arts (BCA)
1775 Broadway
New York, NY 10019
(212) 664-0600

Chamber Musics America
545 Eighth Avenue
New York, NY 10018
(212) 244-2772

Church Music Association of America
548 Lafond Avenue
St. Paul, MN 55103

Cinemists 63
1830 N. Cherokee, Suite 504
Los Angeles, CA 90028
(213) 469-9696

Communications Workers of America (CWA)
1925 K Street, N.W.
Washington, D.C.

Concert Artists Guild
154 West 57th Street
New York, NY 10019

Concert Music Broadcasters Association
500 Temple
Detroit, MI 48201

Council for Research for Music Educations
Univeristy of Illinois School of Music
Urbana, IL 61801

Council of Film Organizations
334 W. 54th Street
Los Angeles, CA 90037
(213) 752-5811

Country Music Association (CMA)
7 Music Circle No.
Nashville, TN 37203
(615) 242-0303

Dramatists Guild
234 West 44th Street
New York, NY 10036
(212) 391-3966

Electronic Industries Association
Consumer Electronics Division
2001 I Street, N.W.
Washington, D.C. 20006
(202) 457-4900

Federal Communications Commission (FCC)
1919 M Street, N.W.
Washington, D.C. 20554
Film Advisory Board
1727½ N. Sycamore
Hollywood, CA 90028
(213) 874-3644

Film Arts Foundation
346 Ninth Street, 2nd Floor
San Francisco, CA 94103
(415) 552-8760

Film/Video Arts
817 Broadway
New York, NY 10003
(212) 673-9361

Foundation for Research in the Afro-American Creative Arts
P.O. Drawer I
Cambria Heights, NY 11411

Foundation for the Extension and Development of the American Professional Theatre (FEDAPT)
165 West 46th Street
New York, NY 10036
(212) 869-9690

Fraternity of Recording Executives
828 East 222nd Street
New York, NY 10427

Gay and Lesbian Media Coalition
4391 Sunset Blvd., #522
Los Angeles, CA 90029
(213) 665-4464

Gospel Music Association
P.O. Box 23201
Nashville, TN 37202

Hebrew Actors Union
31 E. Seventh Street
New York, NY 10003
(212) 674-1923

Illustrators and Matte Artists of Motion Picture, Television, and Amusement Industries

Independent Literary Agents Association
432 Park Avenue S., Suite 1205
New York, NY 10016

Institute for Studies in American Music
Brooklyn College
Music Department
Brooklyn, NY 11210

Institute of Jazz Studies
Rutgers University
Newark, NJ 08903

International Alliance of Theatrical Stage Employees and Moving Picture Machine Operators of the U.S. and Canada
1515 Broadway, Suite 601
New York, NY 10036
(212) 730-1770

International Association of Auditorium Managers
111 E. Wacker Drive
Chicago, IL 60605

International Association of
Independent Producers
P.O. Box 2801
Washington, D.C. 20013
(202) 775-1113

International Association of Music Libraries
Northwestern University
Music Department
Evanston, IL 60201

International Brotherhood of Electrical
Workers (IBEW)
1125 15th Street, N.W.
Washington, D.C.

International Festivals Association
Commodore Court
702 Wayzata Blvd.

International Society of
Performing Arts Administrators
P.O. Box 200328
Austin, TX 78720
(515) 346-1328

International Sound Technicians
15840 Ventura Blvd.
Encino, CA 91436

International Tape/Disc Association
10 Columbus Circle
New York, NY 10019
(212) 965-7110

International Television Association
6311 N. O'Connor Rd., LB51
Irving, TX 75039
(214) 869-1112

Italian Actors Union
184 Fifth Avenue
New York, NY 10010
(212) 675-1003

Jazz-Blues-Gospel Hall of Fame, Inc.
600 S. Dearborn St., #306
Chicago, IL 60605
(312) 922-2433

Jazz Composers Orchestra Association
(JCOA)
500 Broadway
New York, NY

Louis Braille Foundation for Blind Musicians
215 Park Avenue South
New York, NY

Metropolitan Opera Guild
1865 Broadway
New York, NY 10023

Motion Picture Editors Guild
Local 776/IATSE
7715 Sunset Blvd.
Los Angeles, CA

Museums Collaborative
15 Gramercy Park South
New York, NY 10003
(212) 674-0030

Music and Arts Society of America
P.O. Box 9751
Washington, D.C. 20016
(301) 990-1426

Music Critics Association
6201 Tuckerman Lane
Rockville, MD 20852
(301) 530-9527

Music Performance Trust Funds
1501 Broadway
New York, NY 10036
(212) 391-3950

Musicians Foundation
200 West 55th Street
New York, NY 10019
(212) 247-5332

Musicians National Hotline Association
277 E. 6100 South
Salt Lake City, UT 84107
(801) 268-2000

Mutual Musicians Foundation
1823 Highland
Kansas City, MO 64108
(816) 421-9297

National Academy of Jazz
12501 Chandler Blvd., #107
North Hollywood, CA 91607

National Academy of Recording Arts and
Sciences (NARAS)
4444 Riverside Drive
Burbank, CA 91505
(213) 843-8233

National Academy of Songwriters (NAS)
6381 Hollywood Blvd.
Hollywood, CA 90028
(213) 463-7178

National Assembly of State Arts Agencies
(NASAA)
1010 Vermont Avenue, N.W.
Washington, D.C. 20005
(202) 347-6352

National Association for American
Composers and Conductors
133 West 69th Street
New York, NY

National Association of Broadcasters
1771 N Street, N.W.
Washington, D.C.
(202) 293-3500

National Association of Composers
Box 49652
Barrington Station
Los Angeles, CA 90049
(213) 541-8213

National Association of Music Merchants
500 N. Michigan Avenue
Chicago, IL 60611
(312) 527-3200

National Association of Negro Musicians
P.O. Box S-011
237 E. 115th Street
Chicago, IL 60628
(312) 779-1325

National Association of Performing Arts
Managers and Agents
104 Franklin Street
New York, NY 10013
(212) 226-2000

National Association of Record
Merchandisers (NARM)
1008 F. Astoria Blvd.
Cherry Hill, NJ 08034
(609) 427-1404

National Black Music Caucus
400 Central Park West - 16K
New York, NY 10019

National Consortium for Computer Based
Music
University of Illinois
Music Department
Urbana, IL 61801

National Endowment for the Arts (NEA)
2401 E Street, N.W.
Washington, D.C. 20506

National Endowment for the Humanities
(NEH)
806 15th Street, N.W.
Washington, D.C. 20506

National Jazz Service Organizations
P.O. Box 19033
Washington, D.C. 20036
(202) 393-8585

National Music Council
45 W. 34th Street, Suite 1010
New York, NY 10001
(212) 563-3734

National Music Publishers Association
110 East 59th Street
New York, NY 10022
(212) PL1-1930

National Opera Association
Route 2, Box 196
Commerce, TX 75428
(214) 886-3830

National Sheet Music Society
1597 Fair Park Avenue
Los Angeles, CA 90041

The Newspaper Guild
8611 Second Avenue
Silver Spring, MD 20910
(301) 585-2990

Opportunity Resources for the Arts (OR)
1501 Broadway
New York, NY 10036
(212) 575-1688

Performing Arts Resources
270 Lafayette St., Suite 809
New York, NY 10012
(212) 966-8658

Performing Artservices
463 West Street
New York, NY 10014
(212) 989-4953

Producers Guild of America (PGA)
400 S. Beverly Drive
Beverly Hills, CA 90212
(213) 557-0807

Radio Advertising Bureau
304 Park Avenue South
New York, NY 10010
(212) 254-4800

Radio and TV Registry
850 Seventh Avenue
New York, NY 10019

Recording Industry Association of America,
Inc. (RIAA)
888 Seventh Avenue
New York, NY 10106
(212) 765-4330

Screen Actors Guild (SAG)
7065 Hollywood Blvd.
Hollywood, CA 90028
(213) 465-4600

Screen Extras Guild (SEG)
3629 Cahuenga Blvd. West
Los Angeles, CA 90068
(213) 851-4301

Society for Asian Music
50 Washington Square S.
New York, NY 10021

Society for Ethnomusicology
Morris Hall 005
Indiana University
Bloomington, IN 47405
(812) 855-6672

Society of Authors' Representatives
Ten Astor Place, 3rd Floor
New York, NY 10003
(212) 353-3709

Society of Motion Picture and Television Art
Directors
14724 Ventura Blvd., Penthouse
Sherman Oaks, CA 91403
(818) 905-0599

Society of Photographers and Artist
Representatives
1123 Broadway, #914
New York, NY 10010
(212) 924-6023

Society of Stage Directors and
Choreographers
1501 Broadway, 31st Floor
New York, NY 10036
(212) 391-1070

Songwriters Guild
276 Fifth Avenue
New York, NY 10001
(212) 686-6820

TAG Foundation Ltd. (Technical Assistance
Group)
463 West Street
New York, NY 10014
(212) 691-3500

Theatre Development Fund (TDF)
1501 Broadway
New York, NY 10036
(212) 221-0885

United Scenic Artists (USA)
575 Eighth Avenue
New York, NY 10018
(212) 736-4498

U.S. Copyright Office
Registrar
Library of Congress
Washington, D.C. 20540

U.S. Department of Labor
Publishing Office
Washington, D.C. 20210

U.S. Government Printing Office
Superintendent of Documents
Washington, D.C. 20402

Video Software Dealers Association
1008 F Astoria Blvd.
Cherry Hill, NJ 08034
(609) 424-7117

Women Band Directors National Association
(WBDNA)
344 Overlook Drive
West Lafayette, IN 47906

Women in Film
6464 Sunset Blvd., #660
Hollywood, CA 90028
(213) 463-6040

Women's Independent Film Exchange
50 W. 96th Street
New York, NY 10025
(212) 749-1250

Writers Guild of America East
555 West 57th Street
New York, NY 10036

Writers Guild of America West
8955 Beverly Blvd.
Los Angeles, CA